© Gallimard

About the Author

The Franco-Czech novelist MILAN KUNDERA was born in Brno and has lived in France, his second homeland, since 1975. He is the author of the novels *The Joke*, *Farewell Waltz*, *Life Is Elsewhere*, *The Book of Laughter and Forgetting*, *The Unbearable Lightness of Being*, and *Immortality*, and the short-story collection *Laughable Loves*—all originally written in Czech. His most recent novels, *Slowness*, *Identity*, and *Ignorance*, as well as his nonfiction works *The Art of the Novel*, *Testaments Betrayed*, *The Curtain,* and *Encounter*, were originally written in French.

Books by Milan Kundera

The Joke
Laughable Loves
Life Is Elsewhere
Farewell Waltz
(EARLIER TRANSLATION: *The Farewell Party)*
The Book of Laughter and Forgetting
The Unbearable Lightness of Being
Immortality
Slowness
Identity
Ignorance

Jacques and His Master (PLAY)

The Art of the Novel (ESSAY)
Testaments Betrayed (ESSAY)
The Curtain (ESSAY)
Encounter

MILAN KUNDERA

THE CURTAIN

An Essay in Seven Parts

Translated from the French
by Linda Asher

HARPER PERENNIAL

NEW YORK • LONDON • TORONTO • SYDNEY

HARPER PERENNIAL

FIRST HARPER PERENNIAL EDITION PUBLISHED 2008.

Designed by Susan Turner

The Library of Congress has catalogued the hardcover edition as follows:
Kundera, Milan.
[Rideau. English]
The curtain: an essay in seven parts / Milan Kundera;
translated from the French by Linda Asher.—1st ed.
p. cm.
ISBN 978-0-06-084186-7
1. Literature—Philosophy. 2. Fiction—History and criticism. I. Title.

PN49.K8613 2007
801—dc22

ISBN 978-0-06-084195-9 (pbk.)

HB 09.06.2023

CONTENTS

Contents

Contents

Contents

Part One

THE CONSCIOUSNESS
OF CONTINUITY

The Consciousness of Continuity

THEY USED TO TELL A STORY ABOUT MY FATHER, WHO WAS a musician. He is out with friends someplace when, from a radio or a phonograph, they hear the strains of a symphony. The friends, all of them musicians or music buffs, immediately recognize Beethoven's Ninth. They ask my father, "What's that playing?" After long thought he says, "It sounds like Beethoven." They all stifle a laugh: my father doesn't recognize the Ninth Symphony! "Are you sure?" "Yes," says my father, "Late Beethoven." "How do you know it's late?" He points out a certain harmonic shift that the younger Beethoven could never have used.

The anecdote is probably just a mischievous little invention, but it does illustrate the consciousness of continuity, one of the distinguishing marks of a person belonging to the civilization that is (or was) ours. Everything, in our eyes, took on the quality of a history, seemed a more or less logical sequence of events, of attitudes, of works. From my early youth I knew the exact chronology of my favorite writers' works. Impossible to think

Apollinaire could have written *Alcools* after *Calligrammes*, because if that were the case he would have been a different poet, his whole work would have a different meaning. I love each of Picasso's paintings for itself, but I also love the whole course of his work understood as a long journey whose succession of stages I know by heart. In art, the classic metaphysical questions—Where do we come from? Where are we going?—have a clear, concrete meaning, and are not at all unanswerable.

History and Value

LET US IMAGINE A CONTEMPORARY COMPOSER WRITING A sonata that in its form, its harmonies, its melodies resembles Beethoven's. Let's even imagine that this sonata is so masterfully made that, if it had actually been by Beethoven, it would count among his greatest works. And yet no matter how magnificent, signed by a contemporary composer it would be laughable. At best its author would be applauded as a virtuoso of pastiche.

What? We feel aesthetic pleasure at a sonata by Beethoven and not at one with the same style and charm if it comes from one of our own contemporaries? Isn't that the height of hypocrisy? So then the sensation of beauty is not spontaneous, spurred by our sensibility, but instead is cerebral, conditioned by our knowing a date?

No way around it: historical consciousness is so thoroughly inherent in our perception of art that this anachronism (a Beethoven piece written today) would be *spontaneously* (that is,

without the least hypocrisy) felt to be ridiculous, false, incongruous, even monstrous. Our feeling for continuity is so strong that it enters into the perception of any work of art.

Jan Mukarovsky, the founder of structural aesthetics, wrote in Prague in 1932: "Only the presumption of objective aesthetic value gives meaning to the historical evolution of art." In other words: in the absence of aesthetic value, the history of art is just an enormous storehouse of works whose chronologic sequence carries no meaning. And conversely: it is only within the context of an art's historical evolution that aesthetic value can be seen.

But what objective aesthetic value can we speak of if each nation, each historical period, each social group has tastes of its own? From the sociological viewpoint the history of an art has no meaning in itself but is part of a society's whole history, like the history of its clothing, its funeral and marriage rituals, its sports, or its celebrations. That is roughly how the novel is discussed in the Diderot and d'Alembert *Encyclopédie* (1751–72). The author of that entry, the Chevalier de Jaucourt, acknowledges that the novel has a broad reach ("nearly everyone reads it") and a moral influence (sometimes worthwhile, sometimes noxious), but not a specific value in itself; and furthermore, he mentions almost none of the novelists we admire today: not Rabelais, not Cervantes, not Quevedo, nor Grimmelshausen, nor Defoe, nor Swift, nor Smollett, nor Lesage, nor the Abbé Prévost; for the Chevalier de Jaucourt the novel does not stand as autonomous art or history.

Rabelais and Cervantes. That the encyclopedist did not cite

either one of them is no shock: Rabelais hardly worried about whether he was a novelist or not, and Cervantes believed he was writing a sarcastic epilogue to the fantastical literature of the previous period; neither saw himself as "a founder." It was only *in retrospect,* over time, that the practice of the art of the novel assigned them the role. And it did so not because they were the first to write novels (there were many other novelists before Cervantes), but because their works made clear—better than the others had—the raison d'être of this new epic art; because for their successors the works represented the first great novelistic *values*; and only when people began to see the novel as having a value—a specific value, an aesthetic value—could novels in their succession be seen as a history.

Theory of the Novel

FIELDING WAS ONE OF THE FIRST NOVELISTS ABLE TO CON-ceive a poetics of the novel: each of the eighteen books of *Tom Jones* opens with a chapter devoted to a kind of theory of the novel (a light, playful theory, for that's how a novelist theorizes—he holds jealously to his own language, flees learned jargon like the plague).

Fielding wrote his novel in 1749, thus two centuries after *Gargantua* and *Pantagruel* and a century and a half after *Don Quixote,* and yet even though he looks back to Rabelais and Cervantes, for him the novel is still a new art, so much so that he calls himself "the founder of a new province of writing . . ." That

"new province" is so new that it has no name yet! Or rather, in English it has two names—novel and romance—but Fielding refuses to use them because no sooner is it discovered than the "new province" is invaded by "a swarm of foolish novels and monstrous romances," with which he does not want his own books confused. He therefore designates this new art by a rather convoluted but remarkably accurate expression: "prosai-comi-epic writing."

He tries to define the art—that is, to determine its raison d'être, to outline the realm of reality it should illuminate, explore, grasp: "the provision, then, which we have here made is no other than *Human Nature*." The assertion only seems banal; readers at the time saw novels as amusing, edifying, entertaining stories, but nothing more; no one would have granted the novel a purpose so general, thus so exacting, so serious, as an inquiry into "human nature"; no one would have elevated it to the rank of a reflection on man as such.

In *Tom Jones*, Fielding suddenly interrupts himself in mid-narration to declare that he is dumbfounded by one of the characters, whose behavior the writer finds "the most unaccountable of all the absurdities which ever entered into the brain of that strange prodigious creature man"; in fact, astonishment at the "inexplicable" in "that strange . . . creature man" is for Fielding the prime incitement to writing a novel, the reason for *inventing* it. "Invention" is the key word for Fielding; he refers to its Latin source—*inventio*, meaning "discovery, or finding out." In inventing his novel the novelist discovers an aspect of "human nature" till then unknown, concealed; so a novelistic invention is

an act of knowing that Fielding defines as "a quick and saga-cious penetration into the true essence of all the objects of our contemplation." (A remarkable sentence: the adjective "quick" indicates that he is speaking of a particular kind of knowing, in which intuition is fundamental.)

And the form of that "prosai-comi-epic writing"? "As I am the founder of a new province of writing, I am at liberty to make what laws I please therein," Fielding proclaims, and he rejects out of hand any rules or limits which the literary bureaucrats or "clerks"—his term for critics—would try to dictate to him; in his view the novel is defined (and I see this as essential) by its raison d'être; by the realm of reality it has to "discover"; its form, how-ever, arises in a freedom that no one can delimit and whose evo-lution will be a perpetual surprise.

Poor Alonzo Quijada

POOR ALONZO QUIJADA MEANT TO ELEVATE HIMSELF INTO THE legendary figure of a knight-errant. Instead, for all of literary history, Cervantes succeeded in doing just the opposite: he cast a legendary figure down: into the world of prose. "Prose": the word signifies not only a nonversified language; it also signifies the concrete, everyday, corporeal nature of life. So to say that the novel is the art of prose is not to state the obvious; the word defines the deep sense of that art. Homer never wondered whether, after their many hand-to-hand struggles, Achilles or Ajax still had all their teeth. But for Don Quixote and Sancho

teeth are a perpetual concern—hurting teeth, missing teeth. "You must know, Sancho, that no diamond is so precious as a tooth."

But prose is not merely the difficult or vulgar side of life, it is also a certain beauty, till then neglected: the beauty of modest sentiments, for instance the fondness tinged with familiarity that Sancho feels toward Don Quixote. The Don reproaches him for his garrulous informality, saying that none of the texts on chivalry shows any squire daring to speak to his master in such a tone. Of course not: Sancho's affection is one of the Cervantean discoveries of the new prosaic beauty: "A baby could convince him that it's midnight at high noon—and for his simple heart I love him like my own life, and all his eccentricities could not make me leave him," Sancho says.

Don Quixote's death is the more moving for being prosaic, that is to say devoid of all pathos. He has already dictated his will, and then for three days he lingers dying, surrounded by people who love him: yet "that does not keep the niece from eating, the housekeeper from drinking, or Sancho from being of good cheer. For the fact of inheriting something erases or lessens the sorrow man owes to Death."

Don Quixote tells Sancho that Homer and Virgil were describing characters not "as they were but rather as they must be, to stand as examples of virtue to future generations." Now, Don Quixote himself is far from an example to follow. Characters in novels do not need to be admired for their virtues. They need to be understood, and that is a completely different matter. Epic heroes conquer or, if they are themselves con-

quered, they retain their grandeur to the last breath. Don Quixote is conquered. And with no grandeur whatever. For it is clear immediately: human life as such is a defeat. All we can do in the face of that ineluctable defeat called life is to try to understand it. That—that is the raison d'être of the art of the novel.

The Despotism of "Story"

TOM JONES IS A FOUNDLING CHILD, RAISED AND EDUCATED as the ward of Squire Allworthy in his country manse; as a young man Tom falls in love with Sophia, the daughter of a rich neighbor, and when his love bursts into the open (at the end of Book 6), his enemies vilify him so treacherously that Mr. Allworthy casts him out in a fury; then begin Tom's long wanderings (recalling the composition of the "picaresque" novel, in which a lone protagonist, a *picaro*, lives through a series of adventures, meeting new characters in each), and only toward the end (in Books 17 and 18) does the novel return to the principal story line: after a flurry of startling revelations, the enigma of Tom's origins comes clear: he is the natural son of Allworthy's cherished sister, long dead; he triumphs and, in the very last chapter of the novel, weds his beloved Sophia.

When Fielding proclaims his complete freedom with the novel form, he is thinking primarily of his refusal to allow the novel to be reduced to that causal chain of actions, attitudes, gestures, words that the English call "story" and that is seen as constituting the meaning and the essence of a novel; against that

absolutist power of story he particularly claims the right to inter-
rupt the narration "as often as I see occasion," with the interpo-
lation of his own comments and thoughts—with, in a word,
digressions. Nonetheless he too utilizes story as though it is the
only possible means to assure unity in a composition, to bind the
start to the finish. Thus he closed *Tom Jones* (though possibly
with a secret ironic smile) with the "happy ending" of wedding
bells.

Seen from this perspective *Tristram Shandy*, written fifteen
years later, comes as the first radical and total dethroning of
"story." Whereas Fielding, so as not to suffocate in the long cor-
ridor of a causal chain of events, flung wide the windows of
digressions and episodes throughout, Sterne renounces story
completely; his novel is just one big manifold digression, one
long festival of episodes whose "unity"—deliberately fragile,
comically fragile—is stitched together by only a few eccentric
characters and their microscopic, laughably pointless actions.

People like to compare Sterne to the great twentieth-century
revolutionaries of the novel form; with good reason, except that
Sterne was no *poète maudit*; he was hailed by a broad audience;
he carried out his grand feat of dethronement with a smile, with
a laugh, with a guffaw. And no one called him difficult or
incomprehensible; if he irritated it was by his lightness, his fri-
volity, and even more by the shocking *insignificance* of the topics
he wrote about.

Those who deplored that "insignificance" were using the
right term. But we should remember what Fielding said: "The
provision, then, which we have here made is no other than

11

Human Nature." Now, are great dramatic actions really the best clue to understanding human nature? Are they not, rather, a barrier that hides life as it truly is? Isn't "insignificance" actually one of our greatest problems? Isn't that our fate? And if so, is that fate our good fortune or bad? Our humiliation or, on the contrary, our solace, our escape, our idyll, our refuge?

These questions were unexpected and provocative. It was the formal play of *Tristram Shandy* that allowed them to be asked. In the art of the novel, existential discoveries are inseparable from the transformation of form.

In Search of Present Time

DON QUIXOTE LAY DYING, AND YET "THAT DID NOT KEEP the niece from eating, the housekeeper from drinking, or Sancho from being of good cheer." For a brief moment, that sentence parts the curtain that hides life's prose. But suppose we examine the prose more closely? In detail? Moment by moment? How does Sancho's good cheer express itself? Is he talkative? Is he chatting with the two women? About what? Does he keep close by his master the whole time?

By definition, what a narrator recounts is a thing that has happened. But each little event, as it becomes the past, loses its concrete nature and turns into an outline. Narration is recollection, therefore a summary, a simplification, an abstraction. The true face of life, of the prose of life, is found only in the present moment. But how to recount past events and give them back the

presentness they've lost? The art of the novel found a solution: presenting the past in *scenes*. A scene, even one recounted in the grammatical past tense, is ontologically the present: we see and hear it; it unfolds before us here and now.

When they were reading Fielding, his readers became *auditors* fascinated by a brilliant man who held them breathless with what he was telling. Balzac, some eighty years later, turned his readers into *spectators* watching a screen (a movie screen before the fact) on which his novelist's magic made them see scenes they could not tear their eyes away from.

Fielding was not inventing impossible or unbelievable stories; yet the plausibility of what he was recounting was the least of his concerns; he wanted to dazzle his audience not by the illusion of reality but by the enchantment of his storymaking, of his unexpected observations, of the surprising situations he created. But later, when the novel's magic came to lie in the visual and auditory evocation of scenes, *plausibility became the supreme rule*, the condition *sine qua non* for the reader to believe in what he was seeing.

Fielding took little interest in daily life (he would not have believed that banality itself could one day become a major subject for novels); he did not pretend to put a microphone to the thoughts going through his characters' heads (he would observe them from the outside and offer lucid and often humorous hypotheses on their psychology); description bored him, and he spent no time on the physical appearance of his protagonists (you won't learn the color of Tom's eyes) or on the book's historical background; his narration glided happily above the scenes, of

which he would evoke only fragments he considered indispensable for the clarity of the plot and for the idea; the London where Tom's destiny unfolds looks more like a small circle marked on a map than like any actual metropolis: the streets, the squares, the mansions are neither described nor even named.

The nineteenth century began amid decades of explosive events that, time and again and from top to bottom, transfigured the whole of Europe. Something essential in man's existence changed then, and forever: History became everybody's experience; man began to understand that he was not going to die in the same world he had been born into; the clock of History began to toll the hour in loud tones, everywhere, even within novels whose time was immediately counted and dated. The shape of every little object—every chair, every skirt—was stamped with its imminent disappearance (transformation). The era of descriptions began. (Description: compassion for the ephemeral; salvaging the perishable.) Balzac's Paris is nothing like Fielding's London; its squares have their names, its houses their colors, its streets their smells and sounds: it is the Paris of a particular moment, Paris as it had not been before that moment and as it would never be again. And every scene of the novel is stamped (be it only by the shape of a chair or the cut of a suit) by History which, now that it has emerged from the shadows, sculpts and re-sculpts the look of the world.

A new constellation shone in the sky above the novel's high road into its great century, the century of its popularity, its power; an "idea of what the novel is" took hold then, and it would rule the art of the novel until Flaubert, until Tolstoy, until

Proust; it would shroud in semioblivion the novels of earlier centuries (an amazing detail: Zola never read *Dangerous Liaisons*!) and make difficult any future transformation of the novel.

The Multiple Meanings of the Word "History"

"THE HISTORY OF GERMANY," "THE HISTORY OF FRANCE": The complement differs in those two phrases, whereas the notion of "history" retains the same meaning. "The history of mankind," "the history of technology," "the history of science," "the history of this or that art": not only are the complements different, but even the word "history" means something different in each case.

The great Doctor A invents an ingenious method of treating an illness. But ten years later Doctor B devises another treatment, more effective, such that the earlier method (ingenious as it was) is abandoned and forgotten. The history of science has the nature of progress.

Applied to art, the notion of history has nothing to do with progress; it does not imply improvement, amelioration, an ascent; it resembles a journey undertaken to explore unknown lands and chart them. The novelist's ambition is not to do something better than his predecessors but to see what they did not see, say what they did not say. Flaubert's poetics does not devalue Balzac's, any more than the discovery of the North Pole renders obsolete the discovery of America.

The history of technology depends little on man and his free-

dom; obedient to its own logic, it cannot be other than what it has been or what it will be; in that sense, it is *nonhuman*; if Edison had not invented the lightbulb, someone else would have. But if Laurence Sterne had not had the wild idea of writing a novel with no "story," no one else would have done it in his stead, and the history of the novel would not be the one we know.

"A history of literature, unlike history as such, ought to list only the names of victories, for its defeats are no victory for anyone." That brilliant line of Julien Gracq's draws out all the implications of the fact that "unlike history as such," the history of literature is not a history of events but the *history of values*. Without Waterloo the history of France would be incomprehensible. But the Waterloos of minor and even major writers belong in oblivion and nowhere else.

"History as such," the history of mankind, is the history of things that no longer exist and do not join directly in our lives. The history of art, because it is the history of values, thus of things we need, is always present, always with us; we listen to Monteverdi and Stravinsky at the same concert.

And since they are always with us, the values of works of art are constantly being challenged, defended, judged, and judged again. But how to judge them? In the realm of art there are no precise measures for that. Each aesthetic judgment is a *personal wager*; but a wager that does not close off into its own subjectivity; that faces up to other judgments, seeks to be acknowledged, aspires to objectivity. In the collective consciousness, the history of the novel over its whole span from Rabelais to our own time is thus in constant transformation, shaped by competence and

incompetence, intelligence and stupidity, and above all, forgetting, which never stops enlarging its enormous cemetery where, alongside nonvalues, lie buried values that have been underestimated, unrecognized, or forgotten. This inevitable injustice makes the history of art profoundly *human*.

The Beauty of a Sudden Density of Life

IN DOSTOYEVSKY'S NOVELS THE CLOCK CONSTANTLY MARKS the time: "It was about nine in the morning" is the first line in *The Idiot*; at that moment, by pure coincidence (yes, the novel opens with an enormous coincidence!), three characters who have never met before gather in a train compartment: Mishkin, Rogozhin, Lebedev; their conversation soon turns to the book's heroine, Nastasya Filippovna. At eleven o'clock, Mishkin calls at General Epanchin's house; at eleven thirty he is dining with the general's wife and three daughters; Nastasya Filippovna appears once again in the conversation; we learn that a certain Totsky, who had been keeping her, is trying very hard to marry her off to Epanchin's secretary, Ganya, and that in the course of a party for her twenty-fifth birthday that evening she is to announce her decision. Lunch over, Ganya takes Mishkin back to his family's apartment; totally unexpected, Nastasya Filippovna comes in and, shortly after that (every scene in Dostoyevsky is accented by unexpected appearances), Rogozhin arrives, drunk and accompanied by other drunks. Nastasya's party that night is full of agitation: Totsky impatiently awaits the wedding announcement,

Mishkin and Rogozhin both declare their own love to her, and Rogozhin hands her, besides, a packet of a hundred million rubles, which she flings into the fireplace. The party ends late in the night, and with it the first of the novel's four parts: in some 250 pages, fifteen hours of one day and only four settings—the train, Epanchin's house, Ganya's apartment, Nastasya's apartment.

Until then such a concentration of events within so compressed a time and space could only be found in the theater. Behind an extreme dramatization of actions (Ganya slaps Mishkin, Varya spits in Ganya's face, Rogozhin and Mishkin declare their love to the same woman at the same moment), every aspect of ordinary life vanishes. This is the poetics of the novel in Scott, in Balzac, in Dostoyevsky: the novelist wants to tell everything by scenes, but describing a scene takes too much space; the need to maintain suspense requires an extreme density of action, and hence the paradox: the novelist wants to hold on to all the plausibility of life's prose, but the scene becomes so thick with event, so overflowing with coincidence, that it loses both its prosaic nature and its plausibility.

But to me that theatricalization of the scene is not a mere technical necessity, and still less a shortcoming. For that accumulation of events, with whatever it might contain of the exceptional and the barely believable, is above all fascinating! When that happens to us in our own lives—who could deny it?—it fills us with wonder! Delights us! Becomes unforgettable! The scenes in Balzac or in Dostoyevsky (the last great Balzacian of the novel form) reflects a quite particular beauty—a beauty that

is very rare, yes, but nonetheless real, and a kind that everyone has known (or at least glimpsed) in the course of his own life.

It brings to mind the libertine Bohemia of my youth: my friends used to declare that there was no more gorgeous experience for a man than to make love to three different women in a single day. Not as the mechanical workings of an orgy, but as a personal adventure resulting from some unexpected confluence of opportunities, surprises, lightning seductions. That "three-woman day"—extremely rare, dreamlike—had a dazzling charm which, I see today, consisted not in some athletic sexual performance but in the *epic beauty* of a rapid series of encounters in which each woman, seen against the backdrop of the one before, seemed even more unique, and their three bodies were like three long notes played each on a different instrument and bound together in a single chord. It was a quite particular beauty, the *beauty of a sudden density of life*.

The Power of the Pointless

IN 1879, FOR THE SECOND EDITION OF *SENTIMENTAL EDUCATION* (the first was in 1869), Flaubert made changes in the paragraphing: he never broke one into several, but he often linked them into longer paragraphs. This seems to me to reveal his deep aesthetic intention: to *de-theatricalize* the novel; to de-dramatize ("de-balzacize") it; to enclose an action, a gesture, a response within a larger whole; to dissolve them into the running water of the everyday.

The everyday. It is not merely ennui, pointlessness, repetition, triviality; it is beauty as well; for instance, the magical charm of atmospheres, a thing everyone has felt in his own life: a strain of music heard faintly from the next apartment; the wind rattling the windowpane; the monotonous voice of a professor that a lovesick schoolgirl hears without registering; these trivial circumstances stamp some personal event with an inimitable singularity that dates it and makes it unforgettable.

But Flaubert went even further in his investigation of everyday banality. It is eleven in the morning, Emma arrives at her rendezvous in the cathedral and wordlessly hands Léon, her still-platonic lover, the letter saying that she wants no more of their encounters. Then she moves off, kneels, and begins to pray; as she stands up a tour guide approaches and offers to show them around the church. To sabotage the rendezvous, Emma agrees, and the couple is forced to stop at a tomb, look up at the equestrian statue of the dead man, move along to other tombs and other statues, and listen to the guide's recitation, which Flaubert reproduces in all its foolishness and boring length. In a fury, unable to take any more, Léon breaks off the tour, pulls Emma out onto the church square, hails a cab, and there begins the famous scene of which all we see or hear is a man's voice now and then from inside the carriage ordering the driver to turn down yet another new road so that the journey goes on and the lovemaking never ends.

One of the most famous erotic scenes in literature is set off by an utter banality: a silly bore and his dogged chatter. In the theater a great action could only be born of some other great action.

The novel alone could reveal the immense, mysterious power of the pointless.

The Beauty of a Death

WHY DOES ANNA KARENINA KILL HERSELF? THE ANSWER seems clear enough: for years people in her world have turned away from her; she is suffering at the separation from her son, Seryozha; even if Vronsky still loves her, she fears for that love; she is exhausted with it, overexcited, unwholesomely (and unjustly) jealous; she feels trapped. Yes, all that is clear; but is a trapped person necessarily doomed to suicide? So many people adapt to living in a trap! Even if we understand the depth of her sorrow, Anna's suicide remains an enigma.

When Oedipus learns the terrible truth about his identity, when he sees Jocasta hanging, he stabs out his eyes; from the moment he was born a causal inevitability has led him with mathematical certainty toward this tragic denouement. But there is no extraordinary event when Anna, in the seventh part of that novel, first thinks of death as a possibility. It is Friday, two days before her suicide; in torment after a dispute with Vronsky, she suddenly recalls something she had said years back, in excitement, a while after she gave birth: "How is it I am not dead?" and now she lingers long over the line. (Take note: it is not that Anna, seeking a way out of the trap, comes through logic to the notion of death; rather, it is a memory subtly whispering it to her.)

She thinks of death a second time the next day, Saturday: she muses that "the only way to punish Vronsky, to reconquer his love," would be suicide (thus, suicide not as a way out of the trap, but as amorous vengeance); in order to sleep she takes a sedative and loses herself in a sentimental reverie on her own death; she imagines Vronsky bent in torment over her body; then, realizing that her death is only a fantasy, she feels a great surge of joy at life: "No, no, anything but death! I love him, he loves me too, we've been through terrible times like this before and everything worked out."

The following day, Sunday, is the day of her death. In the morning, once again, they argue, and Vronsky has scarcely left to see his mother in her villa outside Moscow when Anna sends him a message: "I was wrong; come back, we must talk. In the name of heaven, come back—I'm frightened!" Then she decides to go visit Dolly, her sister-in-law, to confide her miseries. She climbs into a carriage, sits back, and lets the thoughts flow freely through her head. This is not logical reflection, it is untrammeled brain activity in which everything comes jumbled at once—shreds of thought, observations, memories. The moving carriage is ideal for this sort of silent monologue; the outside world reeling past her eyes is uninterrupted food for her thoughts: "Office and shops. Dentist. Yes, I'm going to tell Dolly everything. It will be hard to do, tell her everything, but I'll do it."

(Stendhal likes to cut off the sound in the middle of a scene; we stop hearing dialogue and start to follow a character's secret thinking; this is always a very logical, condensed reflection by

which Stendhal shows us his hero's strategy as he goes about evaluating the situation and deciding how to respond. Anna's silent monologue, on the other hand, is not at all logical, it is not even a reflection, it is the flood of everything going through her head at a given moment. Here Tolstoy is anticipating what Joyce will do fifty years later, far more systematically, in *Ulysses*—what will be called "interior monologue" or "stream of consciousness." Tolstoy and Joyce were haunted by the same obsession: to seize what occurs in a person's head during a present moment and a moment later will be gone forever. But there is a difference: with his interior monologue, Tolstoy examines not, as Joyce will do later, an ordinary, banal day, but instead the decisive moments of his heroine's life. And that is much harder, for the more dramatic, unusual, grave a situation is, the more the person describing it tends to minimize its concrete qualities, to neglect its nonlogical prose and substitute the implacable and simplistic logic of tragedy. Tolstoy's examination of the *prose of a suicide* is therefore a great achievement, a "discovery" that has no parallel in the history of the novel and never will have.)

When she reaches Dolly's house, Anna is incapable of telling her anything. She soon leaves, climbs back into the carriage, and sets off again; there follows the second interior monologue: street scenes, observations, associations. Back home, she finds the telegram from Vronsky saying that he is in the country with his mother and will not return before ten in the evening. After her emotional cry of that morning ("In the name of heaven, come back—I'm frightened!"), she was hoping for some equally emotional reply and, unaware that Vronsky had not got that mes-

sage, she feels wounded; she decides to take the train and go to him; again she is seated in the carriage, and we hear the third interior monologue: street scenes, a beggarwoman holding a baby, "Why should she imagine she inspires pity? Aren't we all of us flung onto this earth to hate and torment each other? . . . Oh, some schoolboys playing around there. . . . My little Seryozha!"

She leaves her carriage and settles into the train; there a new element enters the scene: ugliness; from the window of her compartment she sees a "misshapen" woman hurrying by on the platform; "mentally she undresses her, to chill herself with the woman's ugliness." The woman is followed by a little girl "laughing affectedly, false and pretentious." A man appears, "filthy and ugly in a military cap." Finally a couple settles into the seat across from her; "she finds them repulsive"; the man is talking "some foolishness to his wife." All rational thought has left her head; her aesthetic perception becomes hypersensitive; a half-hour before she herself is to quit the world she is seeing beauty quit it.

The train stops, and she steps down to the platform. There she is handed a new message from Vronsky confirming his return at ten in the evening. She continues to walk in the crowd, her senses assaulted from all sides by vulgarity, hideousness, mediocrity. A freight train moves into the station. Abruptly she "recalled the man who was crushed the day she first met Vronsky, and she understood what she had to do." And it is only then that she decides to die.

(The "crushed man" she remembers was a railway worker who fell beneath a train at the very moment she saw Vronsky for

the first time. What does it mean, that symmetry, that framing of her whole love story by the motif of a double death at the railway station? Is it a poetic manipulation of Tolstoy's? His way of playing with symbols?

Let us review the situation: Anna has gone to the station to find Vronsky, not to kill herself; once she is on the platform, she is *suddenly* surprised by a memory and seduced by the *unexpected* chance to give her love story a finished, beautiful shape; to tie its beginning to its end by the same railroad station setting and the same motif of death beneath the wheels; for, without knowing it, mankind lives under the seductive spell of beauty, and Anna, stifled by the ugliness of existence, has become all the more susceptible to it.)

She descends a few stairs and reaches the tracks. The freight train draws near. "A sensation gripped her like one she used to feel long ago when, off for a swim, she prepared to plunge into the water."

(A miraculous sentence! In a single second, the last one of her life, the extreme gravity calls up a pleasant, ordinary, lighthearted memory! Even at the poignant moment of her death, Anna is far from Sophocles' tragic way. She does not leave the mysterious way of prose, where ugliness rubs shoulders with beauty, where the rational gives over to illogic, and where an enigma remains an enigma.)

"She drew her head back into her shoulders and, hands stretched before her, fell beneath the train."

The Shame of Repeating Oneself

DURING ONE OF MY FIRST VISITS TO PRAGUE AFTER THE implosion of the Communist regime in 1989, a friend who had lived there the whole while told me: We need a Balzac. Because what you're seeing here is the restoration of a capitalist society with everything cruel and stupid that involves, with the vulgarity of crooks and parvenus. Commercial stupidity has replaced ideological stupidity. But what makes this new experience picturesque is that it's still got the old one fresh in its memory—that the two experiences are telescoped together, and that, like in Balzac's time, History sets up some incredible imbroglios.

And he went on to tell me the story of an old man, a onetime high Party official, who twenty-five years back married off his daughter to the son of a grand-bourgeois family whose property had been expropriated. For a wedding present he promptly arranged a fine career for the boy. Today the old apparatchik is living out his days in isolation; his son-in-law's family has recovered its once-nationalized holdings, and the daughter is ashamed of her Communist father and only dares to see him in secret. My friend laughs: You realize? It's word for word the story of *Père Goriot*! The man who was powerful during the Reign of Terror manages to marry his two daughters off to "class enemies" who later, at the Restoration, won't acknowledge him, and the old papa can never meet with them in public.

We laughed a long time over that. Today I think back on that laughter. Why exactly were we laughing? Was that old apparatchik so ridiculous? Ridiculous for repeating someone else's

experience? But it wasn't he, it was History that was repeating itself. And to do that it's necessary to be without shame, without intelligence, without taste. It's History's poor taste that made us laugh.

That brings me back to my friend's exhortation. Is it true that the period people are living through now in Bohemia cries out for its Balzac? Maybe. Maybe it would be enlightening for the Czechs to read novels about the return of capitalism to their country, a broad, rich novel cycle, with many characters, written like Balzac. But no novelist worthy of the name will write such a novel. It would be ridiculous to write another *Human Comedy*. Because while History (mankind's History) might have the poor taste to repeat itself, the history of an art will not stand for repetitions. Art isn't there to be some great mirror registering all of History's ups and downs, variations, endless repetitions. Art is not a village band marching dutifully along at History's heels. It is there to create its own history. What will ultimately remain of Europe is not its repetitive history, which in itself represents no value. The one thing that has some chance of enduring is the history of its arts.

Part Two

DIE WELTLITERATUR

Maximum Diversity in Minimum Space

WHETHER HE IS NATIONALIST OR COSMOPOLITAN, ROOTED OR
uprooted, a European is profoundly conditioned by his relation
to his homeland; the national problematic is probably more com-
plex, more grave in Europe than elsewhere, but in any case it is
different there. Added to that is another particularity: alongside
the large nations Europe contains small nations, several of which
have, in the past two centuries, attained or re-attained their
political independence. Their existence may have brought me to
understand that cultural diversity is the great European value. In
a period when the Russian world tried to reshape
my small country in its image, I worked out my own ideal of
Europe thus: *maximum diversity in minimum space*. The Russians
no longer rule my native land, but that ideal is even more imper-
iled now.

All the nations of Europe are living a common destiny, but
each is living it differently, based on its own separate experience.
This is why the history of each European art (painting, novel,
music, and so on) seems like a relay race in which the various

nations pass along similar testimony from one to the next. Polyphonic music had its beginnings in France, it continued its development in Italy, attained incredible complexity in the Netherlands, and reached its fulfillment in Germany, in Bach's works; the upwelling of the English novel of the eighteenth century is followed by the era of the French novel, then by the Russian novel, then by the Scandinavian, and so on. The dynamism and long life of the history of the European arts are inconceivable without the existence of all these nations whose diverse experiences constitute an inexhaustible reservoir of inspiration.

I think of Iceland. In the thirteenth and fourteenth centuries a literary work thousands of pages long was born there: the sagas. At the time neither the French nor the English created such a prose work in their national tongues! We should certainly ponder this thoroughly: the first great prose treasure of Europe was created in its smallest land, which even today numbers fewer than three-hundred thousand inhabitants

Irreparable Inequality

THE WORD "MUNICH" HAS BECOME THE SYMBOL OF CAPITU- lation to Hitler. But to be more concrete: at Munich, in the autumn of 1938, the four great nations, Germany, Italy, France and Great Britain, negotiated the fate of a small country to whom they denied the very right to speak. In a room apart the

two Czech diplomats waited all night to be led, the next morning, down long hallways into a room where Chamberlain and Daladier, weary, blasé, yawning, informed them of the death sentence.

"A faraway country of which we know little. . . ." Those famous words by which Chamberlain sought to justify the sacrifice of Czechoslovakia were accurate. In Europe there are the large countries on one side and the small on the other; there are the nations seated in the negotiating chambers and those who wait all night in the antechambers.

What distinguishes the small nations from the large is not the quantitative criterion of the number of their inhabitants; it is something deeper: for them their existence is not a self-evident certainty but always a question, a wager, a risk; they are on the defensive against History, that force that is bigger than they, that does not take them into consideration, that does not even notice them. ("It is only by opposing History as such that we can oppose today's history," Witold Gombrowicz wrote.)

There are as many Poles as there are Spaniards. But Spain is an old power whose existence has never been under threat, whereas History has taught the Poles what it means not to exist. Deprived of their State, they lived for over a century on death row. "Poland has not *yet* perished" is the poignant first line of their national anthem and, in a letter to Czeslaw Milosz some fifty years ago, Gombrowicz wrote a sentence that could never have occurred to any Spaniard: "If, in a hundred years, our language still exists. . . ."

Let's try to imagine that the Icelandic sagas had been written in English: Their heroes' names would be as familiar to us as Tristan or Don Quixote; their singular aesthetic character, oscillating between chronicle and fiction, would have provoked all sorts of theories; people would have argued over whether they should or should not be considered the first European novels. I don't mean to say they have been forgotten; after centuries of indifference they are now being studied in universities throughout the world; but they belong to the "archaeology of letters," they do not influence living literature.

Given that the French are unused to distinguishing between nation and State, I often hear Kafka described as a Czech writer (from 1918 on he was, indeed, a citizen of the newly constituted Czechoslovakia). Of course that is nonsense: Kafka wrote solely in German, need we recall, and he considered himself a German writer. But suppose for a moment he had written his books in Czech. Today who would know them? Before he managed to force Kafka on the world's awareness, Max Brod had to deploy enormous efforts, over the course of twenty years, and that was with the support of the greatest German writers! Even if a Prague editor had managed to publish the books of a hypothetical Czech Kafka, none of his compatriots (that is to say, no Czech) would have had the authority needed to familiarize the world with those extravagant texts written in the language of a "faraway country of which we know little." No, believe me, nobody would know Kafka today—nobody—if he had been a Czech.

Gombrowicz's *Ferdydurke* was published in Polish in 1937. It

had to wait fifteen years finally to be read, and rejected, by a French publisher. And it took a good many years more for the French to see him in their bookstores.

Die Weltliteratur

THERE ARE TWO BASIC CONTEXTS IN WHICH A WORK OF ART may be placed: either in the history of its nation (we can call this the *small context*), or else in the supranational history of its art (the *large context*). We are accustomed to seeing music quite naturally in the large context: knowing what language Orlando de Lassus or Bach spoke matters little to a musicologist, but because a novel is bound up with its language, in nearly every university in the world it is studied almost exclusively in the small, national context. Europe has not managed to view its literature as a historical unit, and I continue to insist that this is an irreparable intellectual loss. Because, if we consider just the history of the novel, it was to Rabelais that Laurence Sterne was reacting, it was Sterne who set off Diderot, it was from Cervantes that Fielding drew constant inspiration, it was against Fielding that Stendhal measured himself, it was Flaubert's tradition living on in Joyce, it was through his reflection on Joyce that Hermann Broch developed his own poetics of the novel, and it was Kafka who showed García Márquez the possibility of departing from tradition to "write another way."

What I just said, Goethe was the first to say: "National literature no longer means much these days, we are entering the era

of *Weltliteratur*—world literature—and it is up to each of us to hasten this development." This is, so to speak, Goethe's testament. Another testament betrayed. For, open any textbook, any anthology: world literature is always presented as a juxtaposition of national literatures . . . as a history of literatures! Of literatures in the plural!

And yet Rabelais, ever undervalued by his compatriots, was never better understood than by a Russian, Bakhtin; Dostoyevsky than by a Frenchman, Gide; Ibsen than by an Irishman, Shaw; Joyce than by an Austrian, Broch. The universal importance of the generation of great North Americans—Hemingway, Faulkner, Dos Passos—was first brought to light by French writers ("In France I'm the father of a literary movement," Faulkner wrote in 1946, complaining of the deaf ear he encountered in his own country). These few examples are not bizarre exceptions to the rule; no, they are the rule: geographic distance sets the observer back from the local context and allows him to embrace the *large context* of world literature, the only approach that can bring out a novel's *aesthetic value*—that is to say: the previously unseen aspects of existence that this particular novel has managed to make clear; the novelty of form it has found.

Do I mean by this that to judge a novel one can do without a knowledge of its original language? I do indeed mean exactly that! Gide did not know Russian, Shaw did not know Norwegian, Sartre did not read Dos Passos in the original. If the books of Witold Gombrowicz and Danilo Kiš had depended solely on the judgment of people who read Polish and Serbo-

Croatian, their radical aesthetic newness would never have been discovered.

(And what about the professors of foreign literatures? Is it not their very natural mission to study works in the context of world literature? Not a chance. In order to demonstrate their competence as experts, they make a great point of identifying with the *small* (national) *context* of the literatures they teach. They adopt its opinions, its tastes, its prejudices. Not a chance—it is in foreign universities that a work of art is most intractably mired in its home province.)

The Provincialism of Small Nations

HOW TO DEFINE "PROVINCIALISM"? AS THE INABILITY (OR the refusal) to see one's own culture in the *large context*. There are two kind of provincialism: of large nations and of small ones. The large nations resist the Goethean idea of "world literature" because their own literature seems to them sufficiently rich that they need take no interest in what people write elsewhere. Kazimierz Brandys says this in his *Paris Notebooks: 1985–87*: "The French student has greater gaps in his knowledge of world culture than the Polish student, but he can get away with it, for his own culture contains more or less all the aspects, all the possibilities and phases of the world's evolution."

Small nations are reticent toward the *large context* for the exact opposite reasons: they hold world culture in high esteem but feel it to be something alien, a sky above their heads, distant,

inaccessible, an ideal reality with little connection to their national literature. The small nation inculcates in its writer the conviction that he belongs to that place alone. To set his gaze beyond the boundary of the homeland, to join his colleagues in the supranational territory of art, is considered pretentious, disdainful of his own people. And since the small nations are often going through situations in which their survival is at stake, they readily manage to present their attitude as morally justified.

Franz Kafka speaks of this in his *Diaries*; from the standpoint of a "large" literature, in this case German, he observes Yiddish and Czech literature: A small nation, he says, has great respect for its writers because they provide it with pride "in face of the hostile surrounding world"; for a small nation, literature is "less a matter of literary history" than "a matter of the people," and it is that exceptional osmosis between the literature and its people that facilitates "the literature's diffusion throughout the country, where it binds with political slogans." From there Kafka arrives at this startling observation: "What in large literatures goes on at a lower level and constitutes a nonindispensable basement of the structure, here takes place in bright light; what there provokes a brief flurry of interest, here brings down nothing less than a life-or-death decree."

These last words remind me of a chorus of Smetana's (composed in Prague in 1864) with the lines: "Rejoice, rejoice, voracious raven, you have a treat in store: soon you will feast on a traitor to our country." How could such a great musician ever offer up such bloodthirsty foolishness? Was it some youthful error? No

excuse there—he was forty then. And actually, what did it even mean at the time, to be a "traitor to our country"? Someone joining up with commando bands to slit the gullets of his fellow citizens? Not at all: a "traitor" was any Czech who decided to leave Prague for Vienna and participate peacefully in German life over there. As Kafka said, what somewhere else "provokes a brief flurry of interest, here brings down nothing less than a life-or-death decree."

A nation's possessiveness toward its artists works as a *small-context terrorism*, reducing the whole meaning of a work to the role it plays in its homeland. I open an old mimeograph copy of some lectures on composition that Vincent d'Indy gave at the Paris Schola Cantorum, where a whole generation of French musicians was trained in the early twentieth century. There are paragraphs on Smetana and Dvořák, particularly on Smetana's two string quartets. What are we told? A single assertion, several times restated in different terms: this "folk-style" music was inspired "by national songs and dances." Nothing else? Nothing. A platitude and a misinterpretation. A platitude, because traces of folk music are found everywhere, in Haydn, in Chopin, in Liszt, in Brahms; a misinterpretation, because Smetana's two quartets are actually a highly personal musical confession, written under tragic circumstances: the composer had just lost his hearing, and these (splendid!) quartets are, he said, "the swirling storm of music in the head of a man gone deaf."

How could Vincent d'Indy be so deeply mistaken? Very probably he was unfamiliar with those works and was simply

repeating what he had heard. His opinion reflected Czech society's idea about these two composers: to make political use of their fame (to display pride "in face of the hostile surrounding world"), it had pulled together scraps of folklore to be found in the music and stitched them into a national banner to fly above the work. The outside world was just accepting politely (or maliciously) the interpretation that was offered.

The Provincialism of Large Nations

AND WHAT ABOUT PROVINCIALISM IN THE LARGE NATIONS? The definition is the same: the inability (or the refusal) to imagine one's own culture in the *large context*. A few years ago, before the end of the past century, a Paris newspaper polled thirty figures who belonged to a kind of intellectual establishment of the day: journalists, historians, sociologists, publishers, and a few writers. Each was asked to name, in order of importance, the ten most notable books in the whole history of France, and from those combined thirty lists the paper compiled an honor panel of a hundred works. Even though the question as asked ("What are the books that have made France what it is?") might allow for several interpretations, still the outcome does give a rather good picture of what a French intellectual elite today considers important in its country's literature.

Victor Hugo's *Les Misérables* came in first. That will surprise a foreign writer. Never having considered the book important

either for himself or for the history of literature, he will suddenly see that the French literature he adores is not the same one the French adore. In eleventh place is de Gaulle's *War Memories*. According such value to a book by a statesman, a soldier, would almost never occur outside of France. And yet what is disconcerting is not that, but the fact that the greatest masterpieces appear only farther down the list! Rabelais stands in fourteenth place—Rabelais after de Gaulle! In this connection I read an article by an eminent French university professor saying that his country's literature lacks a founding figure like Dante for the Italians, Shakespeare for the English, and so on. Imagine—in the eyes of his countrymen, Rabelais lacks the aura of a founding figure! Yet in the eyes of nearly every great novelist of our time he is, along with Cervantes, the founder of a whole art, the art of the novel.

And what of the eighteenth-, the nineteenth-century novel, France's glory? *The Red and the Black* stands twenty-second on the list; *Madame Bovary* is twenty-fifth; *Germinal* thirty-second; *The Human Comedy* only thirty-fourth (Is that possible? *The Human Comedy*, without which European literature is inconceivable!); *Dangerous Liaisons* fiftieth; poor *Bouvard and Pécuchet* come trailing in last, like a couple of breathless dunces. And some masterwork novels do not appear at all among the hundred elect: *The Charterhouse of Parma*; *Sentimental Education*; *Jacques the Fatalist* (true, only within the large context of world-literature can the incomparable novelty of that book be appreciated).

And what about the twentieth century? Proust's *In Search of Lost Time*, seventh place. Camus's *The Stranger*, twenty-second. And after that? Very little. Very little of what's called modern literature, nothing at all of modern poetry. As if France's enormous influence on modern art had never occurred! As if, for instance, Apollinaire (absent from this honor list) had not inspired a whole era of European poetry!

And there's something still more astonishing: the absence of Beckett and Ionesco. How many dramatists of the past century have had such power, such influence? One? Two? No more than that. Here's a recollection: the emancipation of cultural life in Communist Czechoslovakia was bound up with the little theaters that were born at the very start of the sixties. It was there that I first saw a performance of Ionesco, and it was unforgettable: the explosion of an imagination, the irruption of a disrespectful spirit. I often said that the Prague Spring began eight years before 1968, with the Ionesco plays staged at the little theater called On the Balustrade.

One might object that the honor panel I describe is evidence less of provincialism than of the recent intellectual orientation that gives ever smaller weight to aesthetic criteria: that the people who voted for *Les Misérables* were thinking not of the book's importance in the history of the novel but of its great social resonance in France. Of course, but that only demonstrates that indifference to aesthetic value inevitably shifts the whole culture back into provincialism. France is not merely the land where the French live, it is also the country other people watch and draw inspiration from. And those are the values (aesthetic, philosoph-

ical) by which a foreigner appreciates works born outside his own country. Once again, the rule holds: these values are hard to perceive from the viewpoint of the *small context,* even if it be the prideful small context of a large nation.

The Man from the East

IN THE NINETEEN-SIXTIES I LEFT MY COUNTRY FOR France, and there I was astonished to discover that I was "an East European exile." Indeed, to the French, my country was part of the European Orient. I hastened to explain to all and sundry what was the real scandal of our situation: stripped of national sovereignty, we had been annexed not only by another country but by a whole other *world*, the world of the European East which, rooted as it is in the ancient past of Byzantium, possesses its own historical problematic, its own architectural look, its own religion (Orthodox), its alphabet (Cyrillic, derived from Greek writing), and also its own sort of communism (no one knows or ever will know what Central-European communism would have been without Russia's domination, but in any case it would not have resembled the communism we did experience).

Gradually I understood that I came from a "far-away country of which we know little." The people around me placed great importance on politics but knew almost nothing about geography: they saw us as "communized," not "taken over." Actually, hadn't the Czechs always been part of the same "Slavic world" as the Russians? I explained that while there is a *linguistic* unity

among the Slavic nations, there is no Slavic *culture*, no Slavic *world*; that the history of the Czechs, like that of the Poles, the Slovaks, the Croats, or the Slovenes (and of course, of the Hungarians, who are not at all Slavic) is entirely Western: Gothic, Renaissance, Baroque; close contact with the Germanic world; struggle of Catholicism against the Reformation. Never anything to do with Russia, which was far off, another world. Only the Poles lived in direct relation with Russia—a relation much like a death struggle.

But my efforts were useless: the "Slavic world" idea persists as an ineradicable commonplace in world historiography. I open the *Universal History* volume of the prestigious "Pléiade" series: in the chapter called "The Slavic World," the great Czech theologian Jan Hus is irremediably separated from the Englishman John Wyclif (whose disciple Hus was), and from the German Martin Luther (who saw Hus as his teacher and precursor). Poor Hus: after being burned at the stake at Constance, now he must suffer through a dreadful eternity in the company of Ivan the Terrible, with whom he would not want to exchange a single word.

Nothing beats an argument from personal experience: in the late 1970s, I was sent the manuscript of a foreword written for one of my novels by an eminent Slavist, who placed me in permanent comparison (flattering, of course; at the time, no one meant me harm) with Dostoyevsky, Gogol, Bunin, Pasternak, Mandelstam, and the Russian dissidents. In alarm, I stopped its publication. Not that I felt any antipathy for those great

Russians; on the contrary, I admired them all, but in their company I became a different person. I still recall the strange anguish the piece stirred in me: that displacement into a context that was not mine felt like a deportation.

Central Europe

BETWEEN THE *LARGE CONTEXT* OF THE WORLD AND THE *SMALL context* of the nation, a middle step might be imagined: say, a *median context*. Between Sweden and the world, that step is Scandinavia. For Colombia, it is Latin America. And for Hungary, for Poland? In my emigration, I tried to work out a response to that question, and the title of a piece I wrote at the time sums it up: *A Kidnapped West, or The Tragedy of Central Europe*.

Central Europe: What is it? The whole collection of the small nations between two powers, Russia and Germany. The easternmost edge of the West. All right, but what nations do we mean? Does it include the three Baltic countries? And what about Romania, tugged toward the East by the Orthodox Church, toward the West by its Romance language? Or Austria, which for a long while represented the political center of that ensemble? Austrian writers are studied exclusively in the context of Germany, and would not be pleased (nor would I be, if I were they) to find themselves returned to that multilingual hodgepodge that is Central Europe. And anyhow, have all those nations shown any clear and enduring wish to create a common

grouping? Not at all. For a few centuries, most of them did belong to a large State, the Hapsburg Empire, which in the end they wished only to flee.

All these comments relativize the import of the Central Europe notion, demonstrate its vague and approximate nature, but at the same time clarify it. Is it true that the borders of Central Europe are impossible to trace in any exact, lasting way? It is indeed! Those nations have never been masters of either their own destinies or their borders. They have rarely been the subjects of history, almost always its objects. Their unity was *unintentional*. They were kin to one another not through will, not through fellow-feeling or through linguistic proximity, but by reason of similar experience, by reason of common historical situations that brought them together, at different times, in different configurations, and within shifting, never definitive, borders.

Central Europe cannot be reduced to "Mitteleuropa" (I never use the term) as it is called, even in their own non-Germanic tongues, by people who know it only through the Vienna window; it is *polycentric*, and looks different seen from Warsaw, from Budapest, or from Zagreb. But from whatever perspective one looks at it, a common history emerges: looking out from the Czech window, I see there, in the mid-fourteenth century, the first Central European university at Prague; in the fifteenth century I see the Hussite revolution foreshadowing the Reformation; in the seventeenth century I see the Hapsburg Empire gradually constructing itself out of Bohemia, Hungary, Austria; I see the wars that, over two centuries, will defend the

West against the Turkish invasion; I see the Counter-Reformation, with the flowering of baroque art that stamps an architectural unity on the whole of that vast territory, right up to the Baltic countries.

The nineteenth century set off patriotism in all those peoples who refused to let themselves be assimilated, that is to say Germanized. Even the Austrians, despite their dominant position within the empire, could not avoid making a choice between their Austrian identity and membership in the great German entity in which they would be dissolved. And how can we not mention Zionism, also born in Central Europe from that same refusal to assimilate, that same desire of the Jews to live as a nation with their own language! One of Europe's fundamental problems, the problem of the small nations, is nowhere else manifested in so revelatory, so focused, and so exemplary a way.

In the twentieth century, after the 1914 war, several independent states rose from the ruins of the Hapsburg Empire, and thirty years later all of them but Austria found themselves under Russian domination: a situation utterly unprecedented in the whole of Central European history! There followed a long period of anti-Soviet revolts: in Poland, in bloodied Hungary, then in Czechoslovakia, and again in Poland, at length and powerfully. To my mind there is nothing more admirable in the Europe of the second half of the twentieth century than that golden chain of revolts that, over forty years, eroded the empire of the East, made it ungovernable, and tolled the death knell of its reign.

The Contrasting Paths of the Modernist Revolt

I DON'T BELIEVE UNIVERSITIES WILL EVER TEACH THE history of Central Europe as a separate discipline; in the dormitory of the hereafter, Jan Hus will always be breathing the same Slavic exhalations as Ivan the Terrible. In fact, would I myself ever have made use of that notion, and so tenaciously, if I had not been rocked by the political drama of my native land? Surely not. There are words drowsing in the mist that, at the right moment, rush to our aid. By merely being defined, the concept of Central Europe unmasked the lie of Yalta, that deal-making among the three victors of the war, who shifted the age-old boundary between the European East and West several hundred kilometers over to the west.

The notion of Central Europe came to my aid on another occasion, too, this time for reasons having nothing to do with politics; it happened when I began to marvel at the fact that the terms "novel," "modern art," "modern novel," meant something other for me than for my French friends. It was not a disagreement; it was, quite modestly, the recognition of a difference between the two traditions that had shaped us. In a brief historical panorama, our two cultures rose up before me as nearly symmetrical antitheses. In France: classicism, rationalism, the libertine spirit, and then in the nineteenth century, the era of the great novel. In Central Europe: the reign of an especially ecstatic strain of baroque art and then in the nineteenth century, the moralizing idyllicism of Biedermeier, the great Romantic poetry, and very few great novels. Central Europe's matchless

strength lay in its music which, from Haydn to Schoenberg, from Liszt to Bartók, over two centuries embraced in itself all the essential trends in European music; Central Europe staggered beneath the glory of its music.

What was "modern art," that intriguing storm of the first third of the twentieth century? A radical revolt against the aesthetic of the past; that is obvious of course, except that the pasts were not alike. In France modern art—anti-rationalist, anti-classicist, anti-realist, anti-naturalist—extended the great lyrical rebellion of Baudelaire and Rimbaud. It found its privileged expression in painting and, above all, in poetry, which was its chosen art. The novel, by contrast, was anathematized (most notably by the surrealists); it was considered outmoded, forever sealed into its conventional form. In Central Europe the situation was different: opposition to the ecstatic, romantic, sentimental, musical tradition led the modernism of a few geniuses, the most original, toward the art that is the privileged sphere of analysis, lucidity, irony: that is, toward the novel.

My Great Pleiades

IN ROBERT MUSIL'S *THE MAN WITHOUT QUALITIES* (1930–41), Clarisse and Walter played four-hand piano, "unloosed like two locomotives hurtling along side by side." "Seated on their small stools, they were irritated, amorous, or sad about nothing, or perhaps each of them about something separate," and only "the authority of the music joined them together. . . . There was

between them a fusion of the kind that occurs in great public panics, where hundreds of people who an instant earlier differed in every way make the same motions, utter the same mindless cries, gape wide their eyes and mouths." They took "those turbulent seethings, those emotional surges from the innermost being—that is to say, that vague turmoil of the soul's bodily understructures—to be the language of the eternal by which all men can be united."

This ironic comment is aimed not only at music; it goes deeper, to music's *lyrical essence*, to that bewitchment that feeds festivals and massacres alike and turns individuals into ecstatic mobs. In this exasperation with the lyrical, Musil reminds me of Franz Kafka who, in his novels, abhors any emotional gesticulation (this sets him radically apart from the German expressionists) and who, he says so himself, writes *Amerika* in opposition to "style overflowing with feeling"; Kafka thereby reminds me of Hermann Broch, who was allergic to "the spirit of opera," especially to the opera of Wagner (that Wagner so adored by Baudelaire, by Proust), which he calls the very model of kitsch (a "genius kitsch," he said); and Broch thereby reminds me of Witold Gombrowicz who, in his famous text *Against Poets*, is reacting to both the deep-rooted Romanticism of Polish literature and to poetry taken as the untouchable goddess of Western modernism.

Kafka, Musil, Broch, Gombrowicz . . . Did they make for a group, a school, a movement? No; they were all solitaries. I have often called them "the Pleiades of Central Europe's great novelists," and, indeed, like the stars in the constellation, each of them was surrounded by empty space, each of them distant from the

others. It seemed all the more remarkable that their work should express a similar aesthetic orientation: they were all *poets* of the novel, which is to say people impassioned by the form and by its newness; concerned for the intensity of each word, each phrase; seduced by the imagination as it tries to move beyond the borders of "realism"; but at the same time impervious to seduction by the *lyrical*; hostile to the transformation of the novel into personal confession; allergic to the ornamentalization of prose; entirely focused on the real world. They all of them conceived the novel to be a great *antilyrical poetry*.

Kitsch and Vulgarity

THE WORD "KITSCH" WAS BORN IN MUNICH IN THE MID-nineteenth century; it describes the syrupy leftover of the great Romantic period. But Hermann Broch, who saw the connection between Romanticism and kitsch as one of inverse proportions, may have come closer to the truth: according to him, kitsch was the dominant style of the nineteenth century (in Germany and in Central Europe), with a few great Romantic works separating out from it as phenomena of exception. People who experienced the secular tyranny of kitsch (an opera-tenor kind of tyranny) feel particular irritation at the rosy veil thrown over reality, at the immodest exhibition of hearts forever deeply moved, at the "bread drenched in perfume" Musil speaks of; kitsch long ago became a very precise concept in Central Europe, where it stands as the *supreme aesthetic evil*.

I do not suspect the French modernists of succumbing to the lure of sentimentality and pomp; but without a long exposure to kitsch, they had not had occasion to develop a hypersensitive aversion to it. Only in 1960, thus a hundred years after it appeared in Germany, was the word first used in France; yet the French translators of Broch's essays in 1966 and of Hannah Arendt in 1974 both still avoided the term "kitsch" and instead used the translation *art de pacotille* (cheap art), thereby rendering incomprehensible their authors' thinking.

Rereading Stendhal's *Lucien Leuwen*, the fashionable drawing-room conversations, I pause over the key words that catch the various attitudes of the participants: *vanité; vulgaire; esprit* (wit—"that vitriolic acid eating at everything"); *ridicule, politesse* ("infinite manners, no feeling"); *bien-pensante* (right thinking). And I ask myself: What is the word that expresses the worst *aesthetic reprobation* the way the notion of kitsch expresses it for me? It finally comes to me: it is the word *vulgaire, vulgarité*. "M. Du Poirier was a creature of the utmost vulgarity, a man who seemed proud of his crass, overfamiliar ways; thus does a pig wallow in mud with a kind of voluptuous pleasure that is insolent toward the spectator."

Scorn for the vulgar inhabited the drawing rooms of the time just as it does in today's. To recall its etymology: "vulgar" comes from *vulgus*, "people"; "vulgar" is what pleases the people; a democrat, a man of the left, a battler for human rights, is obliged to love the people; but he is free to disdain it haughtily for what he finds vulgar.

After the political anathema Sartre had cast upon Camus,

after the Nobel Prize that brought down jealousy and hatred on him, Camus felt very uncomfortable among the Paris intellectuals. I am told that he was further distressed by labels of "vulgarity" attached to him personally: his lowly origins, his illiterate mother; his situation as a *pied noir* (a Frenchman from Algeria) sympathetic to other *pieds noirs*—people so "overfamiliar" (so "crass"); the lightweight philosophy of his essays; and so on. Reading the articles in which such lynching occurred, I note this passage: Camus is "a peasant dressed up in his Sunday best, . . . a man of the people with his gloves in his hand and his hat still on his head, stepping for the first time into the drawing room. The other guests turn away, they know whom they are dealing with." The metaphor is eloquent: not only did he not know what he was supposed to think (he disparaged progress and sympathized with the Algerian French) but, graver yet, he behaved awkwardly in the drawing room (in the actual or figurative sense): he was vulgar.

In France there is no harsher aesthetic reprobation than this. Reprobation that is sometimes justified but that also strikes at the best: at Rabelais. And at Flaubert. "The primary characteristic of *Sentimental Education*," said the famous writer Barbey d'Aurevilly on its publication, "is vulgarity, first and foremost. In our view, the world already has enough vulgar folk, vulgar minds, vulgar things, without further adding to the overwhelming number of these disgusting vulgarities."

I recall the early weeks of my emigration. As Stalinism had already been unanimously condemned, people readily understood the tragedy the Russian occupation meant for my coun-

try, and they saw me as wrapped in an aura of respectable sadness. I remember sitting at a bar with a Parisian intellectual who had given me much support and help. It was our first meeting in Paris and, hovering in the air above us, I could see grand words: persecution, gulag, freedom, banishment from the native land, courage, resistance, totalitarianism, police terror. Eager to banish the kitsch of those solemn specters, I started describing how the fact of being followed, of having police listening-devices in our apartments, had taught us the delectable art of the hoax. A friend and I had switched apartments, and names as well; he, a big womanizer who was regally indifferent to the microphones, had pulled off some of his finest exploits in my studio. Given that the trickiest moment in any amorous adventure is the breakup, my emigration worked out perfectly for him: one fine day the girls and the ladies arrived to find the apartment locked and my name gone from the door, while I was sending off little farewell cards from Paris, with my own signature, to seven women I had never seen.

I'd meant to amuse this man who was dear to me, but his face gradually darkened until finally he said, with the sound of the guillotine dropping, "I don't find that funny."

We remained friendly, but we were never friends. The memory of our first encounter serves as a key to understand our long-unacknowledged difference: What held us apart was the clash of two aesthetic attitudes: the man allergic to kitsch collides with the man allergic to vulgarity.

Antimodern Modernism

"ONE MUST BE ABSOLUTELY MODERN," WROTE ARTHUR
Rimbaud. Some sixty years later Gombrowicz was not so sure.
In *Ferdydurke* (written in Poland in 1937) the Youngblood
family is dominated by the daughter, a "modern highschool
girl." She is mad for the telephone; she disdains the classical
authors; when a gentleman comes to call she "merely looks at
him and, sticking a small wrench between her teeth with her
right hand, offers him her left with total nonchalance."

Her mother is modern, too; she works with a "Committee for
the Protection of Newborns," is active against the death penalty
and for civil liberties; "ostentatiously offhand, she sets out for the
toilet" and emerges from it "prouder than she went in"; as she
grows older, modernity becomes the more indispensable to her
as the sole "substitute for youth."

And papa? He too is modern; he thinks nothing but does
everything to please his daughter and his wife.

In *Ferdydurke*, Gombrowicz got at the fundamental shift that
occurred during the twentieth century: until then mankind was
divided in two—those who defended the status quo and those
who sought to change it. Then the acceleration of History took
effect: whereas in the past man had lived continuously in the
same setting, in a society that changed only very slowly, now the
moment arrived when he suddenly began to feel History moving
beneath his feet, like a rolling sidewalk: the *status quo* was in
motion! All at once, being comfortable with the *status quo* was
the same thing as being comfortable with History on the move!

Which meant that a person could be both progressive and conformist, conservative and rebel, at the same time!

Attacked as a reactionary by Sartre and his bunch, Camus got off the famous remark about people who had "merely set down their armchairs facing in the direction of History"; Camus was right, but he did not know that the precious chair was on wheels, and that for some time already everyone had been pushing it forward—the modern high school girls, their mamas, their papas, as well as all the activists against the death penalty and all the members of the Committee for the Protection of Newborns and, of course, all the politicians, who, as they pushed the chair along, kept their laughing faces turned to the public running along behind them and also laughing, knowing very well that only a person who *delights* in being modern is genuinely modern.

That was when a certain number of Rimbaud's heirs grasped this extraordinary thing: today the only modernism worthy of the name is antimodern modernism.

Part Three

GETTING INTO THE SOUL OF THINGS

Getting Into the Soul of Things

"MY OBJECTION TO HIS BOOK IS THAT *THE GOOD IS TOO much absent*," said Sainte-Beuve in his review of *Madame Bovary*. Why, he asked, does this novel not have in it "a single person who might *console* and *give ease* to the reader by some *picture of goodness*?" Then he points the young author to the right path: "In a remote province in central France, I met a woman, still young, superior in intelligence, *ardent of heart*, restless: a wife but not a mother, with no child to raise, to love, what did she do to make use of her overflowing mind and soul? . . . She set about becoming a diligent *benefactress*. . . . She taught reading and *moral development* to the children of the villages, often few and far between. . . . There are such souls in provincial and rural life; why not show them as well? That is *uplifting*, it is *consoling*, and the picture of humankind is only the more complete for it." (I have emphasized the key terms.)

It is tempting for me to jibe at this morality lesson, which irresistibly recalls the improving exhortations of the recent "socialist realism." But, memories aside, is it really so inappropriate for the

most prestigious French critic of his time to exhort a young writer to "uplift" and "console" his readers by "a picture of goodness," readers who deserve, as do we all, a little sympathy and encouragement? In fact George Sand, in a letter some twenty years later, told Flaubert much the same thing: Why does he hide the "feeling" he has for his characters? Why not show his "personal doctrine" in his novel? Why does he bring his readers "desolation," whereas she, Sand, would rather "console" them? As a friend she admonishes him: "Art is not only criticism and satire."

Flaubert replies that he never sought to write either criticism or satire. He does not write his novels to communicate his judgments to readers. He is after something entirely different: "I have always done my utmost to get into the soul of things." His reply makes it very clear: the real subject of the disagreement is not Flaubert's character (whether he is kind or cruel, cold or compassionate) but the question of what the novel is.

For centuries painting and music were in service to the Church, a fact that in no way lessened their beauty. But putting a novel to the service of an authority, however noble, would be impossible for a true novelist. It makes no sense to try to glorify a State, let alone an army, with a novel! And yet Vladimir Holan, enthralled by the men who liberated his country (and mine) in 1945, wrote *The Soldiers of the Red Army*, beautiful, unforgettable poems. I could imagine a magnificent painting by Frans Hals that would show a "diligent benefactress" surrounded by peasant children whom she is training in "moral development," but only a very foolish novelist could make that

good lady a heroine as an example to "uplift" his readers' minds. For we must never forget: the arts are not all alike; each of them accedes to the world by a different doorway. Among those doorways one is exclusively reserved to the novel.

I say "exclusively" because to me the novel is not a "literary genre," one branch among many of a single tree. We will understand nothing about the novel if we deny that it has its own muse, if we do not see it as an art *sui generis*, an autonomous art. It has its own genesis (which occurred at a moment specific to it); it has its own history, marked by phases that pertain to it alone (the highly important shift from verse to prose in the evolution of dramatic literature has no equivalent in the evolution of the novel; the histories of the two arts are not synchronous); it has its own morality (Hermann Broch said it: the novel's sole morality is knowledge; a novel that fails to reveal some hitherto unknown bit of existence is immoral; thus "getting into the soul of things" and setting a good example are two different and irreconcilable purposes); it has its specific relation to the author's "self" (in order to hear the secret, barely audible, voice of "the soul of things," the novelist, unlike the poet or the musician, must know how to silence the cries of his own soul); it has its timespan for creation (the writing of a novel takes up a whole era in a writer's life, and when the labor is done he is no longer the person he was at the start); it opens itself to the world beyond its national language (ever since Europe added rhyme to rhythm in its poetry, the full beauty of a verse can no longer be transplanted from one language into another; by contrast, faithful translation of a prose work, while difficult , is possible; in the world of novels there are

no state borders; the great novelists who claimed descent from Rabelais had nearly all read him in translation.)

Ineradicable Error

JUST AFTER WORLD WAR II, A GROUP OF BRILLIANT FRENCH intellectuals made famous the word "existentialism," so baptizing a new orientation in not only philosophy but in theater and the novel. As theoretician of his own theater pieces, Sartre, with his great flair for phrasemaking, proclaimed the "theater of situations" as opposed to the "theater of characters." Our goal, he explained in 1946, is "to explore all the situations most common to human experience," the situations that illuminate the major aspects of the human condition.

Who has not sometimes wondered: suppose I had been born somewhere else, in another country, in another time, what would my life have been? The question contains within it one of mankind's most widespread illusions, the illusion that brings us to consider our life situation a mere stage set, a contingent, interchangeable circumstance through which moves our autonomous, continuing "self." Ah, how fine it is to imagine our other lives, a dozen possible other lives! But enough daydreaming! We are all hopelessly riveted to the date and place of our birth. Our "self" is inconceivable outside the particular, unique situation of our life; it is only comprehensible in and through that situation. If two strangers had not come looking for Joseph K. one morning to inform him that he was under indictment, he

would be someone totally different from the person we know.

Sartre's powerful personality, his double status as both philosopher and writer, lends support to the idea that the existential orientation of the twentieth-century theater and novel must come from the influence of a philosophy. This is still the old ineradicable error, the belief that the relation between philosophy and literature goes only one way, that insofar as "professionals of narration" are obliged to have ideas, they can only borrow them from "professionals of thought." Well, the shift that gradually turned the art of the novel away from its fascination with the *psychological* (the exploration of character) and brought it toward *existential* analysis (the analysis of situations that shed light on major aspects of the human condition) occurred twenty or thirty years before the existentialism vogue gripped Europe; and it was inspired not by the philosophers but by the logic of evolution in the art of the novel itself.

Situations

FRANZ KAFKA'S THREE NOVELS ARE THREE VARIANTS OF the same situation: man in conflict not with another man but with a world transformed into an enormous administration. In the first book (written in 1912) the man is called Karl Rossmann and the world is America. In the second (1917) the man is called Joseph K. and the world is a huge tribunal indicting him. In the third (1922) the man is called K. and the world is a village dominated by a castle.

Kafka may turn away from psychology to concentrate on exploring a situation, but that does not mean that his characters are not psychologically convincing, only that the psychological *problematic* has moved to the secondary level: Whether K.'s childhood was happy or sad, whether he was his mama's pet or was raised in an orphanage, whether or not he has some great romance behind him, will have no effect on his destiny or on his behavior. It is by this reversal of the *problematic*, this other means of inquiry into human life, this other means of conceiving a person's identity, that Kafka sets himself off not only from past literature but also from his great contemporaries Proust and Joyce.

"The gnosiologic novel instead of the psychological novel," wrote Broch in a letter explicating the poetics of the *The Sleepwalkers* (written between 1929 and 1932); each book of this trilogy: *1888—Pasenow or Romanticism, 1903—Esch or Anarchy, 1918—Huguenau or Realism* (the dates are part of the titles) is set fifteen years after the preceding one, in a different milieu, with a different protagonist. What makes a single work of the three novels (they are never published separately) is a common *situation*, the supraindividual situation of the historical process that Broch calls the "degradation of values," in face of which each protagonist works out his own attitude: first Pasenow, faithful to the values which are on the point of disappearing before his very eyes; then Esch, obsessed by the need for values but no longer sure how to recognize them; finally Huguenau, who adapts perfectly to a world deserted by values.

I feel somewhat embarrassed mentioning Jaroslav Hašek

among these writers whom, in my "personal history of the novel," I see as the founders of the novel's modernism, because Hašek never gave a hoot whether he was modern or not; he was a popular writer in the old sense—a writer-hobo, a writer-adventurer, who scorned the literary world and was scorned by it, author of a single novel which instantly found a very large audience throughout the world. That said, it seems all the more remarkable that his *Good Soldier Schweik* (written between 1920 and 1923) should reflect the same aesthetic leanings as Kafka's novels (the two writers did live in the same city over the same years) or as Broch's.

"To Belgrade!" cries Schweik; summoned to the draft board, he has himself pushed in a wheelchair through the Prague streets lifting high a pair of borrowed crutches in a martial flourish, to the amusement of the Prague bystanders. It is the day the Austro-Hungarian Empire declared war on Serbia, unleashing the Great War of 1914 (the one that for Broch comes to represent the crumbling of all values, and the final segment of his trilogy.) In order to live danger-free in this world, Schweik so wildly exaggerates his support for the army, the fatherland, the emperor, that no one can tell for sure whether he is a cretin or a clown. Nor does Hašek tell us; we will never know what Schweik is thinking as he spouts his conformist idiocies, and it is precisely because we do not know that he fascinates us. On Prague beer-hall posters he is always shown as short and round, but it was the book's famous illustrator who imagined him that way; Hašek never said a word about Schweik's physical appearance. We

don't know what sort of family he came from. We never see him with a woman. Does he do without? Does he keep them secret? No answers. But what's more interesting is: no questions! What I mean is, we don't care in the slightest whether Schweik likes women or doesn't!

Here we are seeing a quiet but radical shift in aesthetics: the idea that for a character to be "lifelike," "strong," artistically "successful," a writer need not supply all the possible data on him; there is no need to make us believe he is as real as you and I; for him to be strong and unforgettable, it is enough that he fills the whole space of the situation the novelist has created for him. (In this new aesthetic climate the novelist occasionally even decides to remind the reader that nothing he is telling is real, that everything is his invention—like Fellini, at the end of his film *And the Ship Sails On*, where he shows us all the back-stage areas and the mechanics of his theater of illusion.)

What Only the Novel Can Say

THE ACTION OF *THE MAN WITHOUT QUALITIES* TAKES PLACE in Vienna, but as I recall, that name comes up only two or three times in the course of the novel. Like the word "London" in Fielding, the Vienna topography is not mentioned and is even less described. And what is the unnamed city where the very important encounter occurs between Ulrich and his sister Agathe? You couldn't know this: the city is called Brno in

Czech, Brünn in German; I recognized it readily from a few details, because I was born there; no sooner do I say that than I scold myself for going against Musil's intention . . . intention? What intention? Did he have something to hide? Not at all; his intention was purely aesthetic: to concentrate only on the essential; not to draw the reader's attention off to unimportant geographical considerations.

The sense of modernism is often seen in the determination of each of the arts to come as close as possible to its own particular nature, its essence. For instance, lyric poetry rejected anything rhetorical, didactic, embellishing, so as to set flowing the pure fount of poetic fantasy. Painting renounced its documentary, mimetic function, whatever might be expressed by some other medium (for instance, photography). And the novel? It, too, refuses to exist as illustration of an historical era, as description of a society, as defense of an ideology, and instead puts itself exclusively at the service of "what only the novel can say."

I recall the short story "Sheep," by Kenzaburo Oe, (written in 1958): Onto an evening bus full of Japanese riders climbs a band of drunken soldiers from a foreign army; they set about terrorizing a passenger, a student. They force him to take off his pants and show his bare bottom. The student hears muffled laughter all around him. But the soldiers are not satisfied with this lone victim; they force half the other passengers to drop their trousers as well. The bus stops, the soldiers get off, and the trouserless people pull their clothes back on. The other pas-

sengers wake out of their passive state and insist that the humiliated fellows must go to the police and report the foreign soldiers' behavior. One rider, a schoolteacher, sets about hounding the student; he follows him off the bus, walks him to his house, demands his name to publicize his humiliation and condemn the foreigners. The whole thing ends in a burst of hatred between the two. A magnificent story of cowardice, shame, sadistic indecency passing itself off as love for justice. . . . But I mention the story only to ask: Who are those foreign soldiers? They must be Americans, who were occupying Japan after the war. The author does explicitly call the other passengers "Japanese," so why does he not specify the nationality of the soldiers? Political censorship? A matter of style? No. Suppose that, throughout the story, the *Japanese* passengers were facing *American* soldiers! The powerful effect of using that single word, explicitly pronounced, would reduce the story to a political tract—to an accusation against the occupying forces. Just forgoing that one adjective was enough for the political aspect to recede into dim shadow, and for the light to focus on the enigma that most interested the writer, the *existential* enigma.

Because History, with its agitations, its wars, its revolutions and counter-revolutions, its national humiliations, does not interest the novelist for itself—as a subject to paint, to denounce, to interpret. The novelist is not a valet to historians; History may fascinate him, but because it is a kind of searchlight circling around human existence and throwing light onto it, onto its unexpected possibilities, which, in peaceable times, when History stands still, do not come to the fore but remain unseen and unknown.

Thinking Novels

THE NOVELISTS' MANDATE TO "CONCENTRATE ON THE essential" (on what "only the novel can say")—doesn't it support critics who object to an author's reflections as an element alien to the novel form? Indeed, if a novelist utilizes means that are not proper to him, that belong more to the scholar or the philosopher, is that not the sign of his inability to be fully a novelist and nothing but, the sign of his artistic weakness? And moreover: Don't meditative interpolations risk transforming the characters' actions into mere illustration of the author's theses? And again: Doesn't the art of the novel, with its feel for the relativity of human truths, require that the author's opinion stay out of sight, and that all thinking be left to the reader alone?

The answer from Broch and Musil was utterly clear: they flung the doors wide and brought thinking into the novel as no one had ever done before. The essay called "The Degradation of Values" interpolated into *The Sleepwalkers* (it takes up ten chapters scattered through the third novel of the trilogy) is a series of analyses, of meditations, of aphorisms on the spiritual condition of Europe over the course of three decades; impossible to call that essay inappropriate to the novel form, for it is what lights the wall against which the fates of the three protagonists crash, what binds the three novels into one. I can never emphasize it enough: integrating such intellectually rigorous thinking into a novel and making it, so beautifully and musically, an inseparable part of

the composition is one of the boldest innovations any novelist has dared in the era of modern art.

But there is something even more important, in my view: for these two Viennese, thinking is no longer felt to be an unusual element, an interruption; it is hard to call it "digression" for in these *thinking novels* it is *constantly* present, even when the novelist is recounting an action or describing a face. Tolstoy or Joyce had us hear the phrases going through the heads of Anna Karenina or Molly Bloom; Musil tells us what he himself is thinking as he levels his long gaze on Leo Fischel and his nighttime performances:

"A conjugal bedroom, with the lights out, puts a man into the position of an actor who must play before an invisible parterre the flattering, but by now rather stale, role of a hero behaving like a roaring lion. For years now, Leo's dark audience has not given off the faintest applause at the presentation, nor the slightest sign of disapproval, and surely that's enough to rattle the healthiest nerves. In the morning, at breakfast, Klementine was stiff as a frozen corpse and Leo strained to the point of trembling. Their daughter Gerda would see it herself regularly, and from that time on she thought of conjugal life, with horror and bitter disgust, as a catfight in the dark of night." Thus did Musil go into "the soul of things," that is, into the Fischel couple's "soul of coitus." Through the flash of a single metaphor, a *thinking metaphor*, he casts light on their sex life, present and past, and even onto their daughter's future.

To emphasize: novelistic thinking, as Broch and Musil brought

it into the aesthetic of the modern novel, has nothing to do with the thinking of a scientist or a philosopher; I would even say it is purposely a-philosophic, even anti-philosophic, that is to say fiercely independent of any system of preconceived ideas; it does not judge; it does not proclaim truths; it questions, it marvels, it plumbs; its form is highly diverse: metaphoric, ironic, hypothetic, hyperbolic, aphoristic, droll, provocative, fanciful; and mainly it never leaves the magic circle of its characters' lives; those lives feed it and justify it.

Ulrich is in Count Leinsdorf's ministerial office on the day of a major demonstration. A demonstration? Against what? The information is provided but it is secondary; what matters is the phenomenon of the demonstration in itself: What does it mean to demonstrate in the streets, what is the significance of that collective activity so symptomatic of the twentieth century? In stupefaction Ulrich watches the demonstrators from the window; as they reach the foot of the palace, their faces turn up, turn furious, the men brandish their walking sticks, but "a few steps farther, at a bend where the demonstration seemed to scatter into the wings, most of them were already dropping their greasepaint: it would be absurd to keep up the menacing looks when there were no more spectators." In the light of that metaphor, the demonstrators are not men in a rage; they are *actors performing* rage! As soon as the performance is over they are quick to drop their greasepaint! Later, in the 1960s, philosophers would talk about the modern world in which everything had turned into spectacle: demonstrations, wars, and even love; through his "quick and

sagacious penetration" (Fielding), Musil had already long ago discerned the "society of spectacle."

The Man Without Qualities is a matchless existential encyclopedia about its century; when I feel like rereading this book, I usually open it at random, at any page, without worrying what comes before and what follows; even if there is "story" there, it proceeds slowly, quietly, without seeking to attract attention; each chapter *in itself* is a surprise, a discovery. The omnipresence of thinking in no way deprives the novel of its nature as a novel; it has enriched its form and immensely broadened the realm of what *only the novel can discover and say.*

The Frontier of the Implausible
Is No Longer Under Guard

TWO GREAT STARS BRIGHTENED THE SKY OVER THE twentieth-century novel: that of surrealism, with its enchanting call for the fusion of dream and reality, and that of existentialism. Kafka died too soon to know their writers and their aesthetic programs. Still, and remarkably, the novels he wrote anticipated the two aesthetic tendencies and—what's more remarkable still—bound the two together, placed them in a single perspective.

When Balzac or Flaubert or Proust wants to describe someone's behavior within a specific social milieu, any violation of plausibility is out of place, aesthetically inconsistent; but when the novelist focuses his lens on a problematic that is existential,

the obligation to give the reader a plausible world no longer comes into play as rule or necessity. The author can be far more casual about that apparatus of data, descriptions, motivations meant to give his story the appearance of reality. And, in some borderline cases, he can even find it worthwhile to put his characters in a world that is frankly implausible.

After Kafka crossed it, the frontier to the implausible was left with no police, no customs guards, open for good. That was a great moment in the history of the novel, and, lest its meaning be mistaken, I caution that it was not the nineteenth-century German Romantics who were its precursors. Their fanciful imagining had a different meaning: turning away from the real world, it was seeking after a different life; it had little to do with the art of the novel. Kafka was no romantic. Novalis, Tieck, Arnim, E. T. A. Hoffmann were not what he loved. It was André Breton who worshiped Arnim, not he. As a young man, Kafka and his friend Max Brod read Flaubert, passionately, in the French. He studied him. It was Flaubert, the master observer, he took for his teacher.

The more attentively, fixedly, one observes a reality, the better one sees that it does not correspond to people's idea of it; under Kafka's long gaze it is gradually revealed as empty of reason, thus non-reasonable, thus implausible. It is that long avid gaze set on the real world that led Kafka, and other great novelists after him, past the frontier of the plausible.

Einstein and Karl Rossmann

JOKES, ANECDOTES, FUNNY STORIES — I DON'T KNOW WHAT term to choose for the sort of very short comical tale I heard so much of in the old days, for Prague was its world capital. Political jokes. Jewish jokes. Jokes about peasants. And about doctors. And an odd kind of joke about absent-minded professors who for some unknown reason always carried umbrellas.

Einstein finishes a lecture at the university in Prague (yes, he did teach there for a while) and is getting ready to leave the hall. "Herr Professor sir, take your umbrella, it's raining out!" Einstein gazes thoughtfully at his umbrella where it stands in a corner of the room, and answers the student: "You know, my good friend, I often forget my umbrella, so I have two of them. One is at the house, the other I keep at the university. Of course I could take it now since, as you say quite correctly, it is raining. But then I would end up with two umbrellas at the house and none here." And with these words he goes out into the rain.

Kafka's *Amerika* begins with that same motif, an umbrella that is cumbersome, a pest, forever getting misplaced: Karl Rossmann is lugging a heavy trunk through the crowd disembarking from an ocean liner at the port of New York. Suddenly he remembers he's left his umbrella back on the lower deck. He entrusts his trunk to the young fellow he met on the voyage and, as the passage behind him is jammed, he runs down an unfamiliar staircase and loses his way in the corridors below; finally he knocks at the door of a cabin where he finds a man, a coal-stoker, who immediately starts complaining to him about his supervi-

sors; the conversation goes on for some time so the fellow invites Karl to make himself more comfortable, to have a seat on the bunk.

The psychological impossibility of the situation is dazzling. Really, what we're being told—it can't be true! It is a joke, and of course at the end Karl winds up with no trunk and no umbrella! Yes, it's a joke; except that Kafka doesn't tell it the way one tells jokes; he lays it out at length, in careful detail, describing every move such that it appears psychologically credible; Karl climbs awkwardly onto the bunk, laughing embarrassedly at his clumsiness; after listening to the stoker's long account of humiliations, he suddenly realizes with startled clarity that he ought to have "gone and got back his trunk instead of staying here giving advice." Kafka pulls the mask of the plausible over the implausible, which gives this novel (and all his novels) an inimitable magical charm.

In Praise of Jokes

JOKES, ANECDOTES, FUNNY STORIES: THEY ARE THE BEST evidence that a sharp sense of the real and an imagination that ventures into the implausible can make a perfect pairing. Rabelais's Panurge does not know any woman he would care to wed; yet, being of a logical, theoretical, systematic, foresighted turn of mind, he decides to settle immediately, once and for all, the fundamental question of his life: should a man marry or not? He hurries from one expert to another, from a philosopher to a

lawyer, from a clairvoyant to an astrologer, from a poet to a theologian, and after very lengthy investigations he arrives at the certainty that there is no answer to this greatest of all questions. The whole Third Book recounts nothing but this implausible activity, this joke, which turns into a long farcical tour of all the knowledge of Rabelais's time. (Which reminds me that, three hundred years later, *Bouvard and Pécuchet* is also an extended joke that surveys the knowledge of a whole period.)

Cervantes wrote the second part of *Don Quixote* when the first had already been published and known for several years. That suggested a splendid idea to him: the characters Don Quixote meets along his way recognize him as the living hero of the book they have read; they discuss his past adventures with him and give him the opportunity to comment on his own literary image. Well, that's just not possible! It's straight fantasy! A joke!

Then an unexpected event shakes Cervantes: another writer, a stranger, anticipates him by publishing his own sequel to the adventures of *Don Quixote*. In his second part, which he is in the process of writing, the enraged Cervantes attacks the man with ferocious insults. But he also makes prompt use of this ugly incident to create a further fantasy: after all their misadventures Don Quixote and Sancho, exhausted and gloomy, are already on the way back to their village when they meet a certain Don Alvaro, a character from the accursed plagiarism; Alvaro is astounded to hear their names, for he is a close friend of an entirely different Don Quixote and an entirely different Sancho! The meeting takes place just a few pages before the end of the

novel: the characters' unsettling encounter with their own specters; the ultimate proof of the falseness of all things; the melancholy moonglow of the final joke, the farewell joke.

In Gombrowicz's *Ferdydurke*, Professor Pimko decides to turn Joey, a thirty-year-old man, into a boy of seventeen, and force him to spend his days on a high school bench, a student like all the rest. The burlesque situation conceals a question that is actually quite profound: Will an adult systematically treated as an adolescent eventually lose the sense of his true age? More generally: Will the man become what others see and treat him as, or will he muster the strength, despite everything and everyone, to salvage his identity?

Basing a novel on an anecdote, on a joke, must have seemed to Gombrowicz's readers a modernist's provocation. And they would be right: it was that. However, it had very old roots. At the time when the art of the novel was not yet sure of its identity or its name, Fielding called it "*prosai-comi-epic writing*"; it should be kept always in mind: the comic was one of the three mythical fairies leaning over the cradle of the newborn novel.

The History of the Novel as Seen from Gombrowicz's Studio

A NOVELIST TALKING ABOUT THE ART OF THE NOVEL IS NOT a professor giving a discourse from his podium. Imagine him rather as a painter welcoming you into his studio, where you are surrounded by his canvases staring at you from where they lean

against the walls. He will talk about himself, but even more about other people, about novels of theirs that he loves and that have a secret presence in his own work. According to his criteria of values, he will again trace out for you the whole *past* of the novel's history, and in so doing will give you some sense of his own poetics of the novel, one that belongs to him alone and that is therefore, quite naturally, different from that of other writers. So you will feel you are moving in amazement down into History's hold where the novel's *future* is being decided, is coming into being, taking shape, amid quarrels and conflicts and confrontations.

In 1953, in the first year of his *Journal* (he was to keep it over the next sixteen years until he died), Witold Gombrowicz quotes a letter from a reader: "Above all do not comment on your own work! Just write! What a pity that you let yourself be provoked into writing prefaces to your works, prefaces and even commentaries!" To which Gombrowicz replies that he intends to go on explaining himself "as much as he can and for as long as he can," because a writer who cannot talk about his books is not a "complete writer." Let us linger for a moment in Gombrowicz's studio. Here is a list of his likes and dislikes, his "personal version of the history of the novel":

Above all else he loves Rabelais. (The books on Gargantua and Pantagruel are written at a moment when the European novel is just being born, well before any norms; they overflow with possibilities that the novel's future history will bring to pass or will abandon but that, all of them, still live on with us as inspirations: strolls through the implausible, intellectual teases, free-

dom of form. His passion for Rabelais reveals the meaning of Gombrowicz's modernism: he does not reject the tradition of the novel, he claims it but claims it as a whole, with particular attention to the miraculous moment of its beginnings.)

He is fairly indifferent to Balzac. (He resists Balzac's poetics, erected over time into the normative model of the novel.)

He loves Baudelaire. (He supports the revolution of modern poetry.)

He is not fascinated by Proust. (A crossroads: Proust reached the end of a grandiose journey all of whose possibilities he exhausted; Gombrowicz, possessed by the quest for the new, can only take some other route.)

He feels affinities with almost no other contemporary novelist. (Novelists often have astonishing holes in their own reading: Gombrowicz had read neither Broch nor Musil; irritated by the snobs who latched onto Kafka, he was not especially drawn to him; he felt no affinity with Latin American literature; he looked down on Borges as too pretentious for his taste; and he lived in Argentina in a state of isolation: of important writers only Ernesto Sábato paid him attention; Gombrowicz returned the kindly feeling.)

He dislikes nineteenth-century Polish literature (too romantic for him).

In general he is reserved toward Polish literature. (He felt disliked by his compatriots; yet his reserve is not resentment; it expresses his revulsion at being caught in the straitjacket of the small context. About the Polish poet Tuwim he says, "Of any

one of his poems we can say it is 'marvelous,' but if we are asked what Tuwimian element has made world poetry richer, we would really not know what to reply.")

He likes the avant-garde of the 1920s and '30s. (Though mistrustful of its "progressive" ideology, its "promodern modernism," he does share its thirst for new forms, its freedom of imagination. He counsels a young author: first, as in the "automatic writing" of the surrealists, write twenty pages with no rational control, then reread that with a sharp critical eye, keep what is essential and go on that way. It is as if he hoped to hitch the novel's cart to a wild horse called "Drunkenness," alongside a trained horse called "Rationality.")

He has contempt for "commitment literature." (A remarkable thing: he does not inveigh much against writers who subordinate literature to the struggle against capitalism. The paradigm of "commitment art" for him, this writer banned in his now-Communist Poland, is literature that marches under the banner of anti-Communism. From the first year of his *Journal*, he reproaches its manicheanism, its simplifications.)

He dislikes the avant-garde of the 1950s and '60s in France, particularly the "new novel" and the "new criticism" (Roland Barthes). (On the topic of the new novel: "It is paltry. It is monotonous. . . . Solipsism, onanism . . ." On the topic of the new criticism: "The smarter it is, the dumber it is." He was irritated by the dilemma these new avant-gardes were posing for writers: it was either modernism their way (which modernism he found jargon-laden, university-ridden, doctrinaire, out of touch with reality) or else conventional art endlessly turning out the same forms. For

Gombrowicz modernism meant: through new discoveries, advancing along *the inherited path*. As long as that is still possible. As long as the inherited path still exists.)

A Different Continent

IT WAS THREE MONTHS AFTER THE RUSSIAN ARMY HAD occupied Czechoslovakia; Russia was not yet able to dominate Czech society, which was living with anxiety but (for another few months) with a good deal of freedom: the Writers Union, alleged to be the hotbed of the counterrevolution, still had its houses, published its journals, received guests. At the Union's invitation, three Latin American writers came to Prague: Julio Cortázar, Gabriel García Márquez, and Carlos Fuentes. They came quietly, as writers. To see. To understand. To give heart to their Czech colleagues. I spent an unforgettable week with them. We became friends. And just after they left I had the opportunity to read the Czech translation proofs of *One Hundred Years of Solitude*.

I thought about the anathema the surrealists had cast upon the art of the novel, which they stigmatized as antipoetic, closed to any free imagination. Well, García Márquez's novel is free imagination itself. One of the greatest works of poetry I know. Every single sentence sparkles with fantasy, every sentence is surprise, is wonder: the book is a stunning retort to the disdain for the novel as proclaimed in *A Surrealist Manifesto* (and at the same time a fine homage to surrealism—to its inspiration, to its breath, which blew through the century.)

It is also proof that poetry and lyricism are not two sister notions but notions that must actually be kept well apart. For García Márquez's poetry has no relation to lyricism, the author is not confessing, not exposing his soul, he is not drunk on anything but the objective world he lifts into a sphere where everything is simultaneously real, implausible, and magical.

And there's this as well: the whole great nineteenth-century novel made the *scene* the basic element of composition. García Márquez's novel travels a road heading in the opposite direction: in *One Hundred Years of Solitude* there are no scenes! They are completely diluted in the drunken floods of narration. I know no other example of such a style. As if the novel were moving back centuries, toward a narrator who describes nothing, only recounts, but recounts with a freedom of fantasy never seen before.

The Silvery Bridge

A FEW YEARS AFTER THAT PRAGUE ENCOUNTER, I MOVED TO France, where, as chance would have it, Carlos Fuentes was the ambassador from Mexico. I was living in Rennes, and on my brief visits to Paris I would stay at his place, in a garret of his embassy, and we would have breakfasts that stretched into endless discussions. Suddenly I saw my Central Europe as an unexpected neighbor to Latin America: two edges of the West located at its opposite ends; two neglected, disdained, abandoned lands, pariah lands; and the two parts of the world most profoundly marked by the traumatizing experience of the Baroque. I say "traumatizing" for

the Baroque came to Latin America as the art of the conqueror, and it came into my native land carried by an especially bloody Counter-Reformation, which roused Max Brod to call Prague the "city of evil." I was seeing two parts of the world that were familiar with the mysterious marriage of evil and beauty.

We would talk, and a bridge—silvery, light, quivering, shimmering—formed like a rainbow over the century between my little Central Europe and the immense Latin America; a bridge that linked Matyas Braun's ecstatic statues in Prague to the mad churches of Mexico.

And I thought, too, about another affinity between our two homelands: they held key positions in the evolution of the twentieth-century novel: first the Central European novelists of the 1920s and '30s (Carlos called Broch's *Sleepwalkers* the greatest novel of the century); then, some twenty or thirty years later, the Latin American novelists, my contemporaries.

One day I discovered the novels of Ernesto Sábato. In *The Exterminating Angel* (1974), which overflows with thinking like the books of the two earlier Viennese, he says explicitly that in the modern world, abandoned by philosophy and splintered by hundreds of scientific specialties, the novel remains to us as the last observatory from which we can embrace human life as a whole.

A half-century before him, on the other side of the planet (the silvery bridge was still vibrating above my head) the Broch of *The Sleepwalkers*, the Musil of *The Man Without Qualities* thought that same thought. At the time the surrealists were elevating poetry to the topmost rank of the arts, those two were awarding that supreme place to the novel.

Part Four

WHAT IS A NOVELIST?

To Understand, We Must Compare

WHEN HERMANN BROCH WANTED TO BLOCK OUT A CHARAC-
ter, he first seized on the character's essential position and then
progressed to his more individual traits. From the abstract he
moved to the concrete. Esch is the protagonist of the second
novel of *The Sleepwalkers*. In essence, Broch says, he is a rebel.
What is a rebel? The best way to understand the phenomenon,
Broch goes on to say, is by comparison. Broch compares the
rebel to the criminal. What is a criminal? A conservative, who
relies on the present order and wants to join it, who considers
his thefts and his frauds to be professional activity that will
make him a citizen like everyone else. The rebel, by contrast,
fights the established order to bring it under his own domina-
tion. Esch is not a criminal. Esch is a rebel. A rebel like Martin
Luther, Broch says. But why am I discussing Esch? It's the nov-
elist who interests me! And to whom shall we compare the
novelist?

The Poet and the Novelist

TO WHOM SHALL WE COMPARE THE NOVELIST? TO THE LYRIC poet. The content of lyric poetry, Hegel says, is the poet himself; he gives voice to his inner world so as to stir in his audience the feelings, the states of mind he experiences. And even if the poet treats "objective" themes, external to his own life, "the great lyric poet will very quickly move away from them and end up drawing the portrait of himself" (*"stellt sich selber dar"*).

Music and poetry, Hegel says, have an advantage over painting: lyricism. And in lyricism, he continues, music can go still further than poetry, for it is capable of grasping the most secret movements of the inner world, which are inaccessible to words. Thus there does exist an art in this case, music that is more lyrical than lyric poetry itself. From this we can deduce that the notion of lyricism is not limited to a branch of literature (lyrical poetry) but, rather it designates a certain way of being, and that, from this standpoint, a lyric poet is only the most exemplary incarnation of man dazzled by his own soul and by the desire to make it heard.

I have long seen youth as the *lyrical age*, that is, the age when the individual, focused almost exclusively on himself, is unable to see, to comprehend, to judge clearly the world around him. If we start with that hypothesis (necessarily schematic, but which, as a schema, I find accurate), then to pass from immaturity to maturity is to move beyond the lyrical attitude.

If I imagine the genesis of a novelist in the form of an exemplary tale, a "myth," that genesis looks to me like a *conversion story*: Saul becoming Paul; the novelist being born from the ruins of his lyrical world.

A Conversion Story

FROM MY BOOKSHELF I TAKE A COPY OF *MADAME BOVARY*, the pocket edition from 1972. There are two prefaces, one by a writer, Henry de Montherlant, the other by a literary critic, Maurice Bardèche. These men saw nothing wrong with positioning themselves at a distance from the book in whose vestibule they are squatters. Says Montherlant, "Neither wit . . . nor freshness of idea . . . nor alacrity in the writing, nor unexpected soundings of the depths of the human heart, nor expressive discoveries, nor nobility, nor humor: Flaubert lacks genius to an astounding degree." No doubt, he goes on, one might learn something from Flaubert, but on the condition that one grants him no greater value than he's worth, and knows he is not "made of the same stuff as a Racine, a Saint-Simon, a Chateaubriand, a Michelet."

Bardèche seconds the verdict, and recounts the genesis of Flaubert the novelist: in September, 1848, at the age of twenty-seven, he read to a couple of friends the manuscript of *The Temptation of Saint Anthony*, a "great romantic prose piece" (I'm still quoting Bardèche), into which "he put all his heart, all his ambitions," all his "grand thinking." The piece was roundly

condemned, and his friends advised him to drop his "romantic flights," his "great lyrical transports." Flaubert obeyed, and three years later, in September, 1851, he began writing *Madame Bovary*. He did so "without pleasure," Bardèche says, as "a penance" that he "constantly curses and complains" about in his letters: "Bovary bores me, Bovary irritates me, the vulgarity of the subject gives me bouts of nausea," and so on.

I find it hardly likely that, against his will, Flaubert would smother "all his heart, all his ambitions" merely to follow his friends' wishes. No, what Bardèche relates is not the story of a self-destruction. It is the story of a conversion. Flaubert is thirty years old, the appropriate age for tearing away his lyrical chrysalis. Complaining afterward that his characters are mediocre is the tribute he is paying to what has become his passion: the art of the novel and the territory it explores, the prose of life.

The Soft Gleam of the Comical

AFTER A SOCIETY EVENING SPENT IN THE PRESENCE OF HIS beloved Madame Arnoux, Frédéric in Flaubert's *Sentimental Education*, intoxicated with his future, goes home and stands at his mirror. I quote: "He thought himself handsome, and lingered a minute to gaze at his image."

"A minute." In that precise unit of time there is the whole enormity of the scene. He lingers, he gazes, finds himself hand-

some. For a whole minute. Without budging. He is in love, but he is not thinking about the woman he loves, so dazzled is he by his own self. He gazes at the mirror. But he does not see himself looking into the mirror (as Flaubert sees him). He is enclosed in his lyric self and is unaware that the soft gleam of the comical has settled over him and his love.

The anti-lyric conversion is a fundamental experience in the curriculum vitae of the novelist: separated from himself, he suddenly sees that self from a distance, astonished to find that he is not the person he thought he was. After that experience, he will know that nobody is the person he thinks he is, that this misapprehension is universal, elementary, and that it casts on people (for instance, on Frédéric, standing there at the mirror) the soft gleam of the comical. (That gleam of the comical, suddenly discovered, is the silent, precious reward for the novelist's conversion.)

Toward the end of her story, Emma Bovary, after being turned away by her bankers and abandoned by Léon, climbs into a coach. At its open door a beggar "emitted a sort of muffled howl." She instantly "flung him a five-franc coin over her shoulder. It was her whole fortune. *She thought it quite fine, tossing the coin like that.*"

It really was her whole fortune. She was coming to the end. But the last sentence, which I put in italics, reveals what Flaubert saw very well but Emma was unaware of: she did not merely make a generous gesture; *she was pleased with herself* for making it—even in that moment of genuine despair, she did not miss the chance to display her gesture, innocently, wishing to look fine for

her own sake. A gleam of tender irony will never leave her, even as she progresses toward the death that is already so near.

The Torn Curtain

A MAGIC CURTAIN, WOVEN OF LEGENDS, HUNG BEFORE THE world. Cervantes sent Don Quixote journeying and tore through the curtain. The world opened before the knight errant in all the comical nakedness of its prose.

Like a woman who has applied her makeup before hurrying to her first tryst, the world, when it rushes toward us at the moment of our birth, is already made-up, masked, *reinterpreted*. And the conformists won't be the only ones fooled; the rebel types, eager to stand up against everything and everyone, will not realize how obedient they themselves are; they will rebel only against what is interpreted (or pre-interpreted) as worthy of rebellion.

Delacroix, for his famous painting *Liberty Leading the People* copied the setting from the curtain of pre-interpretation: a young woman on a barricade, her stern face, her naked breast inciting fear; at her side, an oaf with a pistol. Little as I care for this picture, it would be absurd to exclude it from what we call great painting.

But a novel that glorifies such conventional poses as these, such hackneyed symbols, does exclude itself from the history of the novel. For it is by tearing through the curtain of pre-interpretation that Cervantes set the new art going; his destructive act echoes and extends to every novel worthy of the name; it is *the identifying sign of the art of the novel*.

Fame

IN *THE HUGOLIADE*, A 1935 PAMPHLET AGAINST VICTOR HUGO, the playwright Eugène Ionesco, who was twenty-six and still living in Romania, wrote, "The characteristic of the biography of famous men is that they wanted to be famous. The characteristic of the biography of all men is that they did not want to be, or they never thought of being, famous men. . . . A famous man is disgusting."

Let us try to sharpen the terminology: a man becomes famous when the number of people who know him is markedly greater than the number he knows. The recognition enjoyed by a great surgeon is not fame: he is admired not by a public but by his patients, by his colleagues. He lives in equilibrium. Fame is a disequilibrium. There are professions that drag it along behind them necessarily, unavoidably: politicians, supermodels, athletes, artists.

Artists' fame is the most monstrous of all, for it implies the idea of immortality. And that is a diabolical snare, because the grotesquely megalomaniac ambition to survive one's death is inseparably bound to the artist's probity. Every novel created with real passion aspires quite naturally to a lasting aesthetic value, meaning to a value capable of surviving its author. To write without having that ambition is cynicism: a mediocre plumber may be useful to people, but a mediocre novelist who consciously produces books that are ephemeral, commonplace, conventional—thus not useful, thus burdensome, thus noxious—is contemptible. This is the

novelist's curse: his honesty is bound to the vile stake of his megalomania.

They Killed My Albertine

TEN YEARS OLDER THAN I, IVAN BLATNÝ (DEAD FOR YEARS now) is the poet I most admired when I was fourteen. In one of his collections, a certain line kept recurring, with a woman's name in it: *"Albertinko, ty,"* which means "Albertine, you." It was an allusion to Proust's Albertine, of course. That name became for me, as an adolescent, the most captivating of all female names.

All I knew of Proust was the spines of the twenty or so volumes of *In Search of Lost Time* in Czech translation, lined up in a friend's bookcase. Because of Blatný, because of his *"Albertinko, ty, "* one day I plunged into them. When I got to the second volume, Proust's Albertine imperceptibly became entangled with my poet's Albertine.

Czech poets adored Proust's work but did not know his biography. Ivan Blatný did not know it. And it was actually fairly late when I myself lost the privilege of that lovely ignorance, when I heard it said that Albertine was inspired by a man, a man Proust was in love with.

But what are they talking about! No matter who inspired her, man or woman, Albertine is Albertine, and that's that! A novel is the product of an alchemy that turns a woman into a

man, a man into a woman, sludge into gold, an anecdote into drama! That divine alchemy is what makes for the power of every novelist, the secret, the splendor of his art!

But it was no use; I did my best to believe that Albertine was an utterly unforgettable woman, but once I'd been told that her model was a man that useless information was lodged in my head like a virus infecting a computer program. A male had slipped in between me and Albertine, he was scrambling her image, undermining her femininity. One minute I would see her with pretty breasts, the next with a flat chest, and every now and then a mustache would appear on the delicate skin of her face.

They killed my Albertine. And I recall Flaubert's words: "The artist must make posterity believe he never lived." Understand the meaning of that line: what the novelist seeks to protect above all is not himself; it is Albertine and Madame Arnoux.

Marcel Proust's Verdict

IN *IN SEARCH OF LOST TIME*, PROUST IS ABSOLUTELY CLEAR: "In this novel . . . there is not one incident that is not fictional . . . , not one character à clef." However tightly bound to the life of its author, Proust's novel stands, without question, at the opposite pole from autobiography: there is in it no autobiographical intention; he wrote it not in order to talk about his life but to show his readers their own lives. "Every reader, as he

reads, is actually the reader of himself. The writer's work is only a kind of optical instrument he provides the reader so he can discern what he might never have seen in himself without this book. The reader's recognition in himself of what the book says is the proof of the book's truth." Those lines of Proust's define not only the meaning of the Proustian novel; they define the meaning of the very art of the novel.

The Ethic of the Essential

BARDÈCHE SUMS UP HIS VERDICT ON *MADAME BOVARY*: "Flaubert missed his calling as a writer! And is that not basically the judgment of so many Flaubert admirers who end up telling you, 'Oh, but if you read his correspondence, what a masterwork, what an exciting man it reveals!'"

I, too, often reread Flaubert's letters, eager to know what he thought about his art and that of other writers. Still, fascinating as the correspondence can be, it is neither a masterwork nor a work. Because "the work," *l'oeuvre*, is not simply everything a novelist writes—notebooks, diaries, articles. It is *the end result of long labor on an aesthetic project*.

I will go still further: "the work" is what the writer will approve in his own final assessment. For life is short, reading is long, and literature is in the process of killing itself off through an insane proliferation. Every novelist, starting with his own work, should eliminate whatever is secondary, lay out for himself and for everyone else *the ethic of the essential*!

But it is not only the writers, the hundreds and thousands of writers; there are also the researchers, the armies of researchers who, guided by some opposite ethic, accumulate everything they can find to embrace the Whole, a supreme goal. The Whole, which includes a mountain of drafts, deleted paragraphs, chapters rejected by the author but published by researchers, in what are called "critical editions," under the perfidious title "variants," which means, if words still have meaning, that anything the author wrote is worth as much as anything else, that it would be similarly approved by him.

The ethic of the essential has given way to *the ethic of the archive*. (The archive's ideal: the sweet equality that reigns in an enormous common grave.)

Reading Is Long, Life Is Short

I AM CHATTING WITH A FRIEND, A FRENCH WRITER; I URGE him to read Gombrowicz. When I run into him sometime later, he is uncomfortable: "I obeyed you, but, honestly, I couldn't understand your enthusiasm." "What did you read?" "*The Possessed.*" "Damn! Why *The Possessed*?"

The Possessed: The Secret of Myslotch appeared in book form only after Gombrowicz's death. It is a popular novel that he published as a young man under a pseudonym, as a serial in a prewar Polish magazine. He never made it a book; he never intended to. Toward the end of his life, a long interview with Dominique de Roux was published in a volume called *A Kind*

of Testament. In it Gombrowicz discusses all of his work. *All of it*. One book after another. Not one word does he utter about *The Possessed*!

I tell the fellow, "You've got to read *Ferdydurke*! Or *Pornografia*!"

He looks at me sorrowfully. "My friend, the life ahead of me is growing short. The time I could spare your author is used up."

The Little Boy and His Grandmother

STRAVINSKY DEFINITIVELY BROKE OFF HIS LONG FRIEND-ship with the orchestra conductor Ernest Ansermet when the latter tried to make cuts in his ballet *Jeu de Cartes*. Later, Stravinsky himself revisited his *Symphonies of Wind Instruments* and made a number of revisions. Hearing of this, Ansermet was indignant: he didn't like the revisions, and he disputed Stravinsky's right to change what he had originally written.

In the first instance as in the second, Stravinsky's reaction was equally apt: It's none of your business, my good fellow! Don't you go carrying on in my work the way you do in your bedroom! Because what an author creates doesn't belong to his papa, his mama, his nation, or to mankind; it belongs to no one but himself; he can publish it when he wants and if he wants; he can change it, revise it, lengthen it, shorten it, throw it in the toilet and flush it down without the slightest obligation to explain himself to anybody at all.

I was nineteen when, in my hometown, a young academic

gave a public lecture; it was during the first months of the Communist revolution, and bowing to the spirit of the time, he talked about the social responsibility of art. After the conference, there was a discussion; what I remember is, the poet Josef Kainar (a man of Blatný's generation, also long dead now), who, in response to the scholar's talk, told this anecdote:

A little boy takes his blind grandmother for a walk. They are strolling down a street and from time to time the little boy says, "Grandma watch out—a root!" Thinking she is on a forest trail, the old woman keeps jumping. Passersby scold the little boy: "Son, you're treating your grandmother so badly!" And the little boy says: "She's my grandma! I'll treat her any way I want!" And Kainar finishes, "That's me, that's how I am about my poetry."

I'll never forget that demonstration of an author's rights proclaimed under the mistrustful gaze of the young revolution.

Cervantes's Verdict

SEVERAL TIMES IN HIS NOVEL, CERVANTES SETS OUT LONG lists of books on chivalry. He gives their titles but does not always feel it necessary to name the authors. At the time, respect for authors and their rights had not yet become customary.

Let us remember: before Cervantes had completed the second volume of his novel, another writer, still unknown, preceded him by publishing, under a pseudonym, his own sequel to the adventures of Don Quixote. Cervantes reacted at the time the way a novelist would react today: with rage. He attacked the

plagiarist violently and proudly proclaimed, "Don Quixote was born for me alone, and I for him. He knew about action, I about writing. He and I are simply one single entity."

Since Cervantes, this has been the primary, fundamental mark of a novel: it is a unique, inimitable creation, inseparable from the imagination of a single author. Before he was written, no one could have imagined a Don Quixote; he was the *unexpected* itself, and, without the charm of the unexpected, no great novel character (and no great novel) would ever be conceivable again.

The birth of the art of the novel was linked to the consciousness of an author's rights and to their fierce defense. The novelist is the sole master of his work; he *is* his work. It was not always thus, and it will not always be thus. But when that day comes, then the art of the novel, Cervantes's legacy, will cease to exist.

Part Five

Aesthetics and Existence

Aesthetics and Existence

WHERE CAN WE LOOK FOR THE DEEPEST REASONS WHY MEN feel sympathy or antipathy for one another, why they may be friends or not? Clarisse and Walter, in *The Man Without Qualities*, are old acquaintances of Ulrich. They appear for the first time on the novel's stage when Ulrich enters their house and sees them playing four-hand piano. "That low-slung idol with the broad muzzle, a cross between bulldog and basset," that awful "megaphone through which the soul sends its cries into the universe like a stag in rut," the piano represents to Ulrich everything he hates most.

That metaphor throws light on the insurmountable disaccord between Ulrich and the couple; a disaccord that seems arbitrary and unjustifiable since it arises not from any conflict of interests and is neither political nor ideological nor religious; the reason it is so hard to grasp is that its roots go too deep, down to the very *aesthetic fundaments* of their persons; music, as we recall Hegel said, is the most lyrical of the arts, more lyrical than lyric

poetry itself. Throughout the whole book, Ulrich will run up against his friends' lyricism.

Later Clarisse is increasingly taken with the cause of Moosbrugger, a murderer condemned to death whom the fashionable world hopes to save by proving him mad and thus innocent. "Moosbrugger is like music," Clarisse says everywhere; and with this illogical pronouncement (purposely illogical because it suits the lyrical spirit to speak in illogical sentences), her soul sends cries of compassion into the Universe. The cries leave Ulrich cold. Not because he wishes the death penalty on a madman, but because he cannot abide the lyrical hysteria of the fellow's supporters.

Aesthetic concepts only began to interest me when I first perceived their existential roots, when I came to understand them as existential concepts: people simple or refined, intelligent or stupid, are regularly faced in life with the beautiful, the ugly, the sublime, the comical, the tragic, the lyrical, the dramatic, with action, peripeteia, catharsis, or, to speak of less philosophical concepts, with agelasty or kitsch or vulgarity; all these concepts are tracks leading to various aspects of existence that are inaccessible by any other means.

Action

EPIC ART IS FOUNDED ON ACTION, AND THE MODEL OF A society in which action could play out in greatest freedom was that of the heroic Greek period; so said Hegel, and he demonstrated it

with *The Iliad*: even though Agamemnon was the prime king, other kings and princes chose freely to join him and, like Achilles, they were free to withdraw from the battle. Similarly the people joined with their princes of their own free will; there was no law that could force them; behavior was determined only by personal motives, the sense of honor, respect, humility before a more powerful figure, fascination with a hero's courage, and so on. The freedom to participate in the struggle and the freedom to desert it guaranteed every man his independence. In this way did action retain a personal quality and thus its poetic form.

Against this archaic world, the cradle of the epic, Hegel contrasts the society of his own period: organized into the state, equipped with a constitution, laws, a justice system, an omnipotent administration, ministries, a police force, and so on. This society imposes its moral principles on the individual, whose behavior is thus determined far more by anonymous wishes coming from the outside than by his own personality. And it is in such a world that the novel was born. Like the epic in earlier times, the novel too is founded on action. But in a novel action is made problematic, appears as a many-faceted question: If action is merely the effect of obedience, does it count as action? And how to distinguish the activity of repetitive gesture from routine? And what does the word "freedom" mean, *in concreto*, in the bureaucratized modern world where the possibilities to act are so minute?

James Joyce and Kafka reached to the farthest limits of these questions. The gigantic Joycean microscope hugely enlarges every minuscule ordinary gesture and thereby transforms an utterly banal day in Bloom's life into a great modern *odyssey*. Hired as a

surveyor, K. arrives in a village prepared to fight for his right to
live there; but the range of his struggle will be a wretched one:
after endless harassments, he manages only to lodge his com-
plaints with a powerless village mayor, then with a drowsing
minor official; nothing more than that; alongside Joyce's modern
odyssey, Kafka's *Castle* is a modern *iliad*. An odyssey and an iliad
dreamed up on the underside of the epic world, whose upside was
no longer accessible.

Some 150 years earlier, Laurence Sterne had already got at the
problematical, paradoxical nature of action. In *Tristram Shandy*
there are only infinitesimal actions; over several chapters father
Shandy tries to pull the handkerchief out of his right pocket with
his left hand while at the same time using his right hand to lift the
wig off his head; over several chapters Doctor Slop is busy undo-
ing the knots, which are too many and too tight, on the sack that
holds the surgical instruments meant to bring Tristram into the
world. That absence of action (or miniaturization of action) is
treated with an idyllic smile (a smile unknown to either Joyce or
Kafka, and that will remain unparalleled throughout the history
of the novel). I think I detect a radical melancholy in that smile: to
act is to seek to conquer; to conquer brings suffering to others:
renouncing action is the only path to happiness and peace.

Agelasts

"THE AFFECTATION OF GRAVITY" IS ALL AROUND HIM, BUT
Parson Yorick, a character in *Tristram Shandy*, sees it as just ras-

cality, "a cloak for ignorance, or for folly." Whenever possible he badgers it by some "drollery or humour of expression." This habit of "unwary pleasantry" becomes dangerous; "every ten jokes got him a hundred enemies," so that "worn out at length" by their vengeance, he "threw down the sword" and finally died "quite broken-hearted." Yes, he has fallen victim to the *agelasts*. Agelast: a neologism Rabelais coined from the Greek to describe people who are incapable of laughter, who do not understand joking. Rabelais detested the agelasts, because of whom, he said, he came close to "never writing another iota." The story of Yorick and the agelasts is Sterne's fraternal salute to his master across two centuries.

There are people whose intelligence I admire, whose decency I respect, but with whom I feel ill at ease: I censor my remarks to avoid being misunderstood, to avoid seeming cynical, to avoid wounding them by some frivolous word. They do not live at peace with the comical. I do not blame them for it; their *agelasty* is deeply embedded in them, and they cannot help it. But neither can I help it and, while I do not detest them, I give them a wide berth. I do not want to end up like Parson Yorick.

Any aesthetic concept (and agelasty is one) raises some bottomless problematic. People who at the time cast ideological (theological) anathema upon Rabelais were driven to do so by something deeper than mere loyalty to an abstract dogma. What drove them was an aesthetic disaccord: a visceral disaccord with the non-serious; anger at the scandal of a misplaced laugh. For if agelasts tend to see sacrilege in every joke, it's because every

joke *is* a sacrilege. There is an irreconcilable incompatibility between the comical and the sacred, and we can only ask where the sacred begins and ends. Is it confined just to the Temple? Or does its domain reach further, does it also annex what are known as the great secular values: maternity, love, patriotism, human dignity? People for whom life is sacred, wholly and unrestrictedly sacred, react with irritation, overt or hidden, to any joke at all, for any joke at all contains the comical, which is in itself an affront to the sacred nature of life.

Unless we understand the agelasts we cannot understand the comical. Their existence gives the comical its full dimension, shows it to be a wager, a risk-taking, reveals its dramatic essence.

Humor

IN *DON QUIXOTE* WE HEAR A KIND OF LAUGHTER THAT ONE might say comes from medieval farces: we laugh at the knight wearing a barber's basin for a helmet, we laugh at his valet when he gets smacked. But alongside that humor, often stereotyped, often cruel, Cervantes gives us the flavor of a very different, more subtle sort of comedy:

A kindly gentleman invites Don Quixote to his home, where he lives with his poet son. After a brief conversation, the son, very proud of his intellect, recognizes the guest to be an irretrievable madman. Then Don Quixote asks the young man to recite his poetry; eagerly the fellow acquiesces, and Don

Quixote praises his talent to the skies; happy and flattered, the son is dazzled by the guest's intelligence and promptly forgets the man's madness. So which of them is madder, the madman praising the rational one, or the rational man who believes the madman's praise? We have moved into the sphere of another sort of comedy, one that is more delicate and infinitely precious. We are laughing not because someone is being ridiculed, mocked, or even humiliated but because a reality is abruptly revealed as ambiguous, things lose their apparent meaning, the man before us is not what he thought himself to be. That is *humor* (the humor Octavio Paz saw as the Modern Era's "great invention," due to Cervantes).

Humor is not a spark that leaps up for a brief moment at the comical dénouement of some situation or story to set us laughing. Its unobtrusive light glows over the whole vast landscape of life. Let us try looking again as if it were a movie reel at the scene I just recounted: the kindly gentleman brings Don Quixote to his manor house and presents his son who, very proud of his intellect, recognizes the guest to be an irretrievable madman. But this time we are ready: we have already seen the young fellow's delight when the irretrievable madman praises his poems; now as we see the scene again, the son, so proud of his intellect, appears comical *from the outset*. That is how the world looks to a grown man with long experience of "human nature" (who looks at life with a sense of watching movie reels he has seen before) and who has long since stopped taking seriously men's seriousness.

And If the Tragic Has Deserted Us?

AFTER SOME PAINFUL EXPERIENCES, CREON UNDERSTOOD that personal passions not brought under control pose a mortal danger to the city; convinced of this, he confronts Antigone, who is protecting from him the no less legitimate rights of the individual. He is unyielding, she dies, and he, crushed by his guilt, determines "never to see another day." *Antigone* inspired Hegel to his magisterial meditation on tragedy: two antagonists face to face, each of them inseparably bound to a truth that is partial, relative, but, considered in itself, entirely justified. Each is prepared to sacrifice his life for it, but can only make it prevail at the price of total ruin for the adversary. Thus both are at once right and guilty. Being guilty is to the credit of great tragic characters, Hegel says. A profound sense of guilt can make possible an eventual reconciliation.

Freeing the great human conflicts from naive interpretation as a struggle between good and evil, understanding them in the light of tragedy, was an enormous feat of mind; it brought forward the unavoidable relativism of human truths; it made clear the need to do justice to the enemy. But moral Manichaeanism has an indestructible vitality: I remember an adaptation of *Antigone* that I saw in Prague shortly after the war; killing off the tragic in the tragedy, its author made Creon a wicked fascist confronted by a young heroine of liberty.

Such political productions of *Antigone* were much in fashion after World War II. Hitler not only brought unspeakable horrors upon Europe but also stripped it of its sense of the tragic.

Like the struggle against Nazism, all of contemporary political history would thenceforth be seen and experienced as a struggle between good and evil. Wars, civil wars, revolutions, counter-revolutions, nationalist struggles, uprisings and their repression have been ousted from the realm of tragedy and dispatched to the authority of judges avid to punish. Is this a regression? A relapse into the pre-tragical stage of humankind? But if so, precisely who has regressed? Is it History itself, usurped by criminals? Or is it our mode of understanding History? Often I think: tragedy has deserted us; and that may be the true punishment.

The Deserter

HOMER NEVER CHALLENGES THE REASONS THAT LED THE Greeks to lay siege to the city of Troy. But Euripides, looking at that same war from the distance of several centuries later, is far from admiring Helen, and he shows the disproportion between the woman's worth and the thousands of lives sacrificed for her. In his *Orestes* he has Apollo say, "The gods used Helen's beauty to start conflict between the Greeks and the Trojans, and by their carnage to unburden the earth of the too-numerous mortals weighing on it." Suddenly everything is clear: the meaning of the most famous war ever had nothing to do with any great cause; its sole purpose was killing. In that case can we still use the term "tragic"?

Ask people the real reason for the 1914 war. No one will be able to answer, even though that gigantic slaughter is at the root

of the whole past century and all its evil. If only someone could tell us that Europeans killed one another this time to redeem a cuckold's honor!

Euripides did not go so far as to consider the Trojan War comical. A novel did do that. Hašek's soldier Schweik feels so little connected to the purposes of the war that he does not even dispute them; he doesn't know what they are; he doesn't try to find out what they are. War is dreadful but he does not take it seriously. You don't take seriously a thing that makes no sense.

There are times when History, its great causes, its heroes, can seem derisory and even comical, but it is difficult, inhuman, even superhuman, to see it that way permanently. Maybe deserters manage to do that. Schweik is a deserter. Not in the juridical sense of the term (a person who leaves the army illegally) but in the sense of his total indifference toward the great collective conflict. From every viewpoint—political, juridical, moral—the deserter looks unpleasant, blameworthy, akin to cowards and traitors. The novelist's eye sees him otherwise: the deserter is one who refuses to grant meaning to the battles of his contemporaries. Who refuses to see a tragic grandeur in massacres. Who is loath to participate as a clown in History's comedy. His vision of things is often lucid, very lucid, but it makes his position difficult to maintain: it loosens his solidarity with his people; it distances him from mankind.

(During the 1914 war, all Czechs felt alien to the goals the Hapsburg Empire had sent them to fight for; Schweik, surrounded by deserters, was thus an unusual deserter: a happy deserter. When I think of the huge popularity he still enjoys in

his country, it occurs to me that such great collective situations—rare, half-secret, unshared by other people—can provide what amounts to a very reason for a nation's existence.)

The Tragic Chain

AN ACTION, HOWEVER INNOCENT IT MAY BE, DOES NOT DIE off in solitude. It provokes, as effect, another action, and sets in motion a whole chain of events. Where does a person's responsibility end for an act that stretches off endlessly into some incalculable, monstrous transformation? In his great speech at the end of *Oedipus Rex*, Oedipus curses the people who long ago salvaged his infant body when his parents tried to discard it; he curses that blind kindness that set off an unspeakable evil; he curses that chain of actions in which the decency of an intention does not matter; he curses that infinite chain that binds all humans together and makes them into a single tragic humanity.

Is Oedipus guilty? This word from the legal lexicon has no meaning here. At the end of *Oedipus Rex*, he gouges out his eyes with the clasps from the tunic of Jocasta, who has hanged herself. Is this an act of justice he wants to impose on himself? The will to self-punishment? Or is it not rather a cry of despair? The wish to see no more of the horrors of which he is both cause and target? Therefore a desire not for justice but for nothingness? In *Oedipus at Colonus*, the last of Sophocles's plays we have, Oedipus—now blind—argues violently against Creon's accusa-

tions and proclaims his innocence, under the approving gaze of Antigone who is wandering with him.

Having had occasion in the past to observe Communist statesmen, I saw with surprise that they were often extremely critical of the reality ensuing from actions of theirs that they saw turn before their eyes into an uncontrollable chain of consequences. If they were really so clear-sighted, you will say, why did they not just quit? Was it out of opportunism? Love of power? Out of fear? Perhaps. But it cannot be ruled out that at least some of them were guided by a sense of responsibility for an act they had helped to set loose in the world and for which they did not want to deny paternity, still cherishing the hope that they would manage to correct it, modify it, give it back meaning. The clearer it became that the hope was illusory, the more clearly emerged the tragedy of their lives.

Hell

IN CHAPTER 10 OF *FOR WHOM THE BELL TOLLS*, HEMINGWAY describes the day the Spanish Republicans (and his sympathies as man and as author lie with them) take a small town held by the Fascists. They condemn some twenty people without trial, and round them up in a town square where they have meanwhile regrouped men armed with flails, pitchforks, and scythes to kill the guilty. The guilty? Most can only be blamed for their passive membership in the Fascist Party, so the executioners, simple folk who know them well and feel no hatred for them, are timid and

reluctant at first; only with the influence of alcohol and then of blood do they work themselves up till the scene (the detailed account of it takes up almost a tenth of the book!) ends in a hideous eruption of cruelty where it all turns into *hell*.

Aesthetic concepts constantly become questions; I wonder: Is History tragic? Or to put it another way: Does the notion of tragic have meaning apart from personal destiny? When History stirs up masses, armies, sufferings, and vengeances, we can no longer distinguish individual wills; tragedy is entirely engulfed by the sewer overflow drowning the world.

In a pinch we might look for the tragic tangled under the rubble of horrors, in the first impulse of people with the courage to risk their lives for their truth.

But there are some horrors beneath which no archaeological dig would find the slightest vestige of tragedy: massacres for money; or worse, for an illusion; still worse, for an idiocy.

Hell (hell on earth) is not tragic; what's hell is horror that has not a trace of the tragic.

Part Six

THE TORN CURTAIN

Poor Alonzo Quijada

A POOR VILLAGE GENTLEMAN, ALONZO QUIJADA, DECIDES TO become a knight-errant, and takes the name Don Quixote de la Mancha. How shall we define his identity? He is the man he is not.

He steals a copper shaving basin from a barber, mistaking it for a helmet. Later the barber turns up by chance in the same tavern where Don Quixote is with some people; the man spots his shaving basin and tries to retrieve it. But Don Quixote proudly refuses to see the helmet as a shaving basin. So an apparently simple object becomes a problem. And moreover, how can it be proved that a shaving basin set upon a head is not a helmet? Amused, the mischievous company decides on the only objective means for demonstrating truth: a secret vote. Everyone in the room takes part, and the outcome is unequivocal: the object is pronounced a helmet. An admirable ontological joke!

Don Quixote is enamored of Dulcinea. He has seen her only fleetingly, or perhaps never. He is enamored but, as he says himself, "only because knights-errant are supposed to be." Infidelities,

betrayals, disappointments of love—all narrative literature has always had those. But in Cervantes it is not the lovers but love, the very notion of love, that is put to the question. For what is love if one loves a woman without knowing her? Just a decision to love? Or even an imitation? The question concerns us all: If, from our childhood on, the examples of love were not there inviting us to copy them, would we know what "loving" means?

A poor village gentleman, Alonzo Quijada, started the history of the art of the novel with three questions about existence: What is a person's identity? What is truth? What is love?

The Torn Curtain

ANOTHER VISIT TO PRAGUE AFTER 1989. FROM A FRIEND'S bookcase I happen to pull out a book by Jaromir John, a Czech novelist of the period between the wars. The book is long forgotten; it is called *The Internal-Combustion Monster*, and I read it for the first time that day. Written around 1932, it tells a story set about ten years earlier, during the first years of the Czechoslovak Republic that was proclaimed in 1918. A Mr. Engelbert, a forestry official in the old regime of the Hapsburg monarchy, moves to Prague to live out his retirement years; but coming up against the aggressive modernity of the young state, he has one disappointment after another. A highly familiar situation. One aspect, though, is brand new: for Mr. Engelbert the horror of this modern world, the curse, is not the power of money or the arrogance of the arrivistes, it is the noise; and not the age-old noise of

a thunderstorm or a hammer, but the new noise of engines, especially of automobiles and motorcycles, the explosive "internal-combustion monsters."

Poor Mr. Engelbert: first he settles in a house in a residential neighborhood; there cars are his first introduction to the evil that will turn his life into an unending flight. He moves to another neighborhood, pleased to see that cars are forbidden entry to his street. Unaware that the prohibition is only temporary, he is exasperated at night when he hears the "internal-combustion monsters" roaring again beneath his window. From then on he never goes to bed without cotton in his ears, realizing that "sleeping is the most basic human desire and that death caused by the impossibility of sleep must be the worst death there is." He goes to seek silence in country inns (in vain), in provincial cities in the houses of onetime colleagues (in vain), and ends up spending his nights in trains, which, with their gentle archaic noise, provide him with a slumber that is relatively peaceful in his life as a beleaguered man.

When John wrote his novel, Prague had probably one car to every hundred inhabitants or, I don't know, perhaps to every thousand. It is precisely when it was still rare that the phenomenon of noise (motor noise) stood out in all its astonishing newness. We can deduce a general rule: the existential import of a social phenomenon is most sharply perceptible not as it expands but when it is just beginning, incomparably fainter than it will soon become. Nietzsche remarks that in the sixteenth century nowhere in the world was the Church less corrupt than in Germany and that was the reason the Reformation started pre-

cisely there, because the mere "beginnings of corruption were felt to be intolerable." Bureaucracy in Kafka's time was an innocent babe compared to today, and yet it was Kafka who revealed its monstrous nature, which since then has become routine and no longer commands anyone's interest. In the 1960s brilliant philosophers subjected the "consumer society" to a critique that over the years has been so cartoonishly outstripped by reality that we are embarrassed to refer to it. For we must recall another general rule: reality is utterly unashamed to repeat itself, but confronted with reality's repetition, thought always ends by falling silent.

In 1920 Mr. Engelbert was still astonished by the noise of the "internal-combustion monsters"; the generations that followed found it natural; after initially horrifying man, sickening him, noise gradually reshaped him; through its omnipresence and its permanence it ultimately instilled in him the *need for noise*, and with that, a whole different relation to nature, to repose, to joy, to beauty, to music (which, now become an uninterrupted background of sound, has lost its character as art) and even speech (which no longer holds a privileged position in the world of sounds). In the *history of existence* this was a change so profound, so enduring, that no war or revolution can produce its like; a change whose beginnings Jaromir John modestly noted and described.

I say "modestly" because John was one of those novelists called "minor"; still, great or small, he was a real novelist; he was not just copying truths stitched on the *curtain of preinterpretation*; he had the Cervantes-like courage to tear the curtain. Let's take

Mr. Engelbert out of the novel and imagine him as a real man who sets about writing his autobiography; no, it is nothing like John's novel! For, like most of his ilk, Mr. Engelbert is accustomed to judging life according to what can be read on that curtain hanging in front of the world; he knows that the phenomenon of noise, however disagreeable it is for him, does not deserve interest. But freedom, independence, democracy—or, seen from the opposite angle, capitalism, exploitation, inequality—yes, oh a hundred times yes! Now, those are serious notions, they can give a life meaning, render a misfortune noble! Thus, in his autobiography, which I envision him writing with cotton stuffed in his ears, he grants great significance to the recovered independence of his homeland, and he rails at the selfishness of the arrivistes; as for those "internal-combustion monsters," he has relegated them to the bottom of the page, a mere mention of a trivial annoyance that, in the end, is rather amusing.

The Torn Curtain of the Tragic

ONCE AGAIN I WANT TO CALL UP THE FIGURE OF ALONZO Quijada; see him mount his Rosinante and set off in search of great battles. He is prepared to sacrifice his life for a noble cause, but tragedy doesn't want him. For, since its birth, the novel is suspicious of tragedy: of its cult of grandeur; of its theatrical origins; of its blindness to the prose of life. Poor Alonzo Quijada. In the vicinity of his mournful countenance, everything turns into comedy.

Probably no other novelist has let himself be seduced more by the pathos of the tragic than Victor Hugo in *Quatrevingt-treize*, his 1874 novel on the great French Revolution. His three protagonists, in their makeup and costume, give the impression that they have stepped straight from the stage to the novel: the Marquis de Lantenac, passionately devoted to the monarchy; Cimourdain, the great figure of the Revolution, equally convinced of its truth; and finally Lantenac's nephew, Gauvain, an aristocrat who under Cimourdain's influence has become a great Revolutionary general.

This is the end of their story: in the midst of a hideously cruel battle in a château besieged by the Revolutionary army, Lantenac manages to escape through a secret passage. Then, already safe from the attackers, from out in the woods, he sees the château aflame and hears a mother's sobs of despair. On the instant he remembers that three children of a republican family are being held hostage behind an iron door whose key is in his pocket. He has already witnessed hundreds of deaths, of men, women, old people, and never flinched. But the death of children—no, never, absolutely never, he cannot allow that! He hurries back along the same underground passage and, before his transfixed enemies, frees the children from the flames. He is arrested and condemned to death. When Gauvain learns of his uncle's heroic action, his moral certainties are shaken: Does not a man who has sacrificed himself to save children's lives deserve to be pardoned? He helps Lantenac to escape, knowing that by so doing he is calling down his own death. Indeed, loyal to the intransigent ethic of the Revolution, Cimourdain sends Gauvain to the guillotine

even though he loves him like a son. For Gauvain the death sentence is just; he accepts it with serenity. As the blade drops, Cimourdain, the great revolutionary, fires a bullet into his own heart.

What makes these characters actors in a tragedy is their total identification with the convictions for which they are prepared to die, and do die. *Sentimental Education*, written five years earlier (1869) and also dealing with a revolution (the one in 1848), takes place in a universe entirely different from the tragic: the characters have their opinions, but the opinions are thin, with no weight, no necessity; the people change views easily, not through some profound intellectual reappraisal but the way they change neckties if the color no longer pleases. When Frédéric refuses Deslauriers the fifteen thousand francs promised for his magazine, immediately Deslauriers's "friendship for Frédéric died. . . . He was swept with a hatred for the rich. He took to Sénécal's views and swore to uphold them." When Madame Arnoux disappointed Frédéric with her chastity, he "wished, like Deslauriers, for some universal upheaval."

Sénécal, the fiercest revolutionary, "the democrat," "the people's friend," becomes a factory director and treats the workers arrogantly. Says Frédéric: "Ah, you're very harsh for a democrat!" Says Sénécal: "Democracy is not the profligate behavior of individualism. It is equality under the law, the distribution of labor, it is order!" The man becomes a revolutionary again during the days of 1848, and then takes up arms against that same revolution. Nonetheless it would be unfair to see him as an opportunist perpetually turning coat. Revolutionary or counter-

revolutionary, he is always the same man. For—and this is an enormous discovery of Flaubert's—what a political attitude rests upon is not an opinion (that very fragile, vaporous thing!) but something less rational and more substantial: for instance, in Sénécal's case, an archetypal attachment to order, an archetypal hatred of the individual (that "profligate behavior of individualism," as he says).

Nothing is more alien to Flaubert than morally judging his characters; their lack of convictions does not make Frédéric or Deslauriers blameworthy or antipathetic; in fact they are far from cowardly or cynical, and they often feel the need for some courageous action; the day of the revolution, in the midst of the crowd, seeing beside him a man hit by a bullet in the small of the back, Frédéric "sprang forward, furious." But these are only passing urges that never turn into a lasting position.

Only the most naive of them all, Dussardier, gets himself killed for his ideal. But his place in the novel is secondary. In a tragedy, tragic destiny is played stage front. In Flaubert's novel we glimpse its fleeting presence only in the background, like a stray gleam of light.

The Fairy

SQUIRE ALLWORTHY HAS HIRED TWO TUTORS FOR THE young Tom Jones: one, Square, is a modern man, open to liberal ideas, to science, to the *philosophes*; the other, Pastor Thwackum, is a conservative for whom the sole authority is religion; two men

who are learned but also mean and stupid. They are perfect pre-figurations of the sinister duo from *Madame Bovary*: the pharmacist, Homais, fan of science and progress, and his counterpart the parish priest, Bournisien, a sanctimonious bigot.

Sensitive as he was to the role of stupidity in life, Fielding saw it as an exception, a random occurrence, a flaw (detestable or comical) that could not deeply affect his view of the world. In Flaubert stupidity is something else; it is not an exception, a random occurrence, a flaw; it is not a phenomenon that is, so to speak, quantitative, the lack of a few molecules of intelligence that could be remedied by education; it is incurable; present everywhere, in the thinking of fools and of geniuses both, it is an indissociable part of "human nature."

We should recall Sainte-Beuve's complaint against Flaubert: in *Madame Bovary* "goodness is too much absent." What!? How about Charles Bovary? Devoted to his wife, to his patients, utterly devoid of selfishness: Is he not a hero, a martyr of goodness? How can we forget him, him who after Emma's death, now knowing about all her infidelities, feels no anger but only an infinite sadness? How can we forget the surgical procedure he cobbled together to fix the clubfoot of Hippolyte, the stable-boy! At that moment all the angels hovered over him—charity, generosity, the love of progress! Everyone cheered him, and even Emma, under the spell of goodness, was moved, and embraced him! A few days later it became clear that the operation was absurd, and after unspeakable suffering Hippolyte had his leg amputated. Charles is left crushed, and pathetically abandoned by everyone. This character so unbelievably, implausibly good and yet so real,

he is surely more worthy of compassion than the "diligent bene-factress" in the provinces who so touched Sainte-Beuve.

No, it is untrue that "goodness is too much absent" in *Madame Bovary*; the hitch is something else: that stupidity is too much present. This is the reason Charles cannot be used as the "uplifting picture" Sainte-Beuve would have liked to see. But Flaubert does not want to produce "uplifting pictures"; he wants to reach into "the soul of things." And in the soul of things, in the soul of *all* things human, everywhere, he sees it dancing, the sweet fairy of stupidity. That unobtrusive fairy adapts marvelously to both good and evil, to both learning and ignorance, to Emma as well as to Charles, to you as to me. Flaubert brought her to the ball of the great enigmas of existence.

Going Down Into the Dark Depths of a Joke

WHEN FLAUBERT TOLD TURGENEV ABOUT HIS PROJECT FOR *Bouvard and Pécuchet*, the Russian urged him strongly to keep the work short. Perfect advice from an old master. For the story can only maintain its comical effectiveness in the form of a short tale; length would make it monotonous and irritating, if not completely silly. But Flaubert persisted; he explained to Turgenev: "If [this subject] is treated briefly, in a light, concise way, it will be a fairly witty fantasy, but without import and without plausibility, whereas in giving it detail and development I would appear to believe in my story, and I could make it something serious and even frightening."

Kafka's *The Trial* depends on a very similar artistic wager. The first chapter (the one Kafka read to his friends, who found it very amusing) could be understood (and quite rightly so, actually) as just a funny little item, a joke: a fellow named K. is surprised in his bed one morning by two very ordinary fellows who for no reason announce his arrest, eat up his breakfast, and carry on in his bedroom with such natural arrogance that K., in his nightshirt, timid and clumsy, cannot think what to do. If, later on, Kafka had not followed that chapter with other, ever darker chapters, nobody these days would be surprised that his friends should have laughed so hard. But Kafka did not want to write (to quote Flaubert) "a fairly witty fantasy"; he wanted to give that humorous situation a larger "import," to "detail and develop" it, to emphasize its "plausibility" in order to give the impression he did "believe in the story," and thereby make of it "something serious and even frightening." He wanted *to go down into the dark depths of a joke*.

Bouvard and Pécuchet, two retirees determined to take possession of every kind of knowledge, are characters in a joke but at the same time characters in a mystery: they have far richer learning than not only the people around them but those who would be reading their story. They know facts, the theories about the facts, even the arguments disputing those theories. Have they got parrot brains and only repeat what they have learned? Even that is untrue; they often display surprising good sense, and we agree totally when they feel superior to the people they frequent, when they grow angry at their stupidity and refuse to tolerate it. And yet nobody doubts that the two fellows are fools. But why do they

seem fools to us? Try to define their foolishness! In fact, try defining foolishness as such! Just what is foolishness? Reason is capable of unmasking the evil hiding treacherously behind a fine lie. But faced with foolishness, reason is powerless. There is nothing to unmask. Foolishness does not wear a mask. It is simply there, innocent. Sincere. Naked. And indefinable.

Again I picture Hugo's great trio, Lantenac, Cimourdain, and Gauvain, those three upright heroes whom no personal interest could divert from the straight line, and I wonder: the thing that gives them the strength to persist in their outlook, *with not the slightest doubt, not the slightest hesitation*: Is it not foolishness? A foolishness proud and noble as if carved in marble? A foolishness that accompanies all three of them loyally, the way, long ago, a goddess from Olympus used to accompany her heroes unto death?

Yes, that is what I think. Foolishness does not diminish in the slightest the grandeur of a tragic hero. Inseparable from "human nature," stupidity is present with man always and everywhere: in the penumbra of bedrooms as well as on the floodlit podiums of History.

Bureaucracy According to Stifter

I WONDER WHO FIRST DISCOVERED THE EXISTENTIAL SIGNIFicance of bureaucracy. Probably Adalbert Stifter. If Central Europe had not become my obsession at a certain point in my life, who knows whether I would have read so attentively this

old Austrian writer whom I initially found rather uncongenial, with his overlong passages, his didacticism, his moralism, his chasteness. But he is the key writer of the Central Europe of the nineteenth century, the pure flower of that era and its idyllic, virtuous mentality that we call Biedermeier! Stifter's most important novel, *Der Nachsommer (Indian Summer),* of 1857, is as voluminous as its tale is simple: a young man, Heinrich, is on a mountain excursion when he is caught short by clouds announcing a storm. He seeks refuge in a manor whose owner, an old aristocrat named Risach, welcomes him kindly and comes to feel friendship for him. The small castle has the lovely name Rosenhaus, "house of roses," and Heinrich returns to it regularly thereafter, for one or two visits a year; in the ninth year he marries Risach's goddaughter. And with that the novel closes.

The book unveils its deep meaning only toward the end, when Risach sits alone with Heinrich and confides his life story. It lies in two conflicts: one private, the other social. I'll describe the second: Risach had in the past been a very high civil servant. One day, realizing that work in the administration was contrary to his nature, to his tastes and interests, he left his position and settled in the country, in his "Rose House," to live there in harmony with nature and the villagers, far from politics, far from History.

His break with the bureaucracy resulted not from his political or philosophical convictions but from his understanding of himself and of his inability to be a civil servant. What does it mean to be a civil servant? Risach describes it to Heinrich, and as far as I know it is the first (and a masterly) phenomenological description of bureaucracy:

As the administration grew broader and bigger, it had to hire an ever greater number of employees, and among them, inevitably, some bad and some even very bad. Thus it was imperative to create a system that would allow necessary operations to be carried out without being damaged or weakened by the unequal levels of competence among the bureaucrats. "To make clear my thinking," Risach continued, "I'd say this: an ideal clock should be constructed in such a way that it works well even if we change its parts, replacing a bad bit with a good one and a good bit with a bad. Such a clock is, of course, inconceivable. But only under just such a form can the administration exist; otherwise, given its development so far, it will die." Thus a civil servant is not required to understand the issues his administration deals with, only to carry out zealously a variety of operations without understanding, or even trying to understand, what goes on in the offices next door.

Risach is not criticizing the bureaucracy, he is merely explaining why, as the person he is, he could not dedicate his life to it. What kept him from being a civil servant was his incapacity to obey and to work for objectives that lay beyond his own horizon. And also "his respect for things as they are in themselves," a respect so profound that, in negotiations, he would not argue for what his superiors required but only for what "things required for themselves."

For Risach is a man of the concrete; he thirsts for a life in which he would do only work whose purpose would be comprehensible to him; in which he would live only among people whose names he knew, whose trade, house, children he knew;

where even time would be constantly visible and savored in its concrete nature: morning, noon, the sun, the rain, the storm, the night.

His break with bureaucracy is one of the memorable breaks of mankind from the modern world. A break both radical and peaceable, as befits the idyllic atmosphere of that strange novel from the Biedermeier period.

The Defiled World of Castle and Village

MAX WEBER WAS THE FIRST OF THE SOCIOLOGISTS FOR whom "capitalism and modern society in general" are characterized *primarily* by "bureaucratic rationalization." He found the socialist revolution (which at the time was only a project) neither dangerous nor salutary, it simply seemed to him useless because it could not solve the main problem of modernity, which is the "bureaucratization" of social life, which, he felt, would proceed inexorably no matter who owned the means of production.

Weber formulated his ideas on bureaucracy between 1905 and his death in 1920. I am tempted to note that a novelist, in this case Adalbert Stifter, was aware of the fundamental importance of bureaucracy fifty years before the great sociologist. But I will not enter the controversy between art and science over priority of discovery, for the two were not aiming at the same thing. Weber did a sociological, historical, political analysis of the phenomenon of the bureaucracy. Stifter set himself a different problem:

What specifically does it mean for a man to live in a bureaucratized world? How does it transform his existence?

Some sixty years after *Indian Summer*, Kafka, that other Central European, writes *The Castle*. For Stifter, the world of castle and village represented the oasis where old Risach fled to escape his high-official career, to live at last content with neighbors, animals, and trees, with "things as they are in themselves." That world, the setting for a good many other works by Stifter (and his disciples) became for Central Europe the symbol of an idyllic, ideal life. And that is the world, a castle with a peaceful village, that Kafka, who read Stifter, shows invaded by offices, an army of civil servants, an avalanche of dossiers! Cruelly he defiles the sacred symbol of the antibureaucratic idyll by giving it a precisely opposite meaning: that of the total victory of total bureaucratization.

The Existential Meaning of the Bureaucratized World

FOR A LONG WHILE NOW THE REVOLT OF A RISACH BREAKING with his civil-service life has no longer been possible. Bureaucracy has become omnipresent, and nowhere can it be escaped; nowhere would one find a "Rose House" and live there in intimate connection with "things as they are in themselves." We have moved irrevocably from Stifter's world to Kafka's.

When in the past my parents went on vacation, they would buy their tickets at the railroad station ten minutes before the train was to leave; they would stay in a country inn where, on the

last day, they would pay their bill in cash to the proprietor. They were still living in Stifter's world.

My vacation takes place in a different world: I buy the tickets two months ahead, standing in line at the travel agency; there a bureaucrat takes me in hand and phones Air France, where other bureaucrats I will never lay eyes on will book me a seat in an airplane and register my name under a number in a passenger list; my room I also book in advance, by telephoning a receptionist who puts my request on her computer and informs its own little administration of it; the day I am to leave, the bureaucrats of a trade union, having quarreled with the Air France bureaucrats, call a strike. After many telephone calls on my part, and without asking my pardon (no one ever asked K.'s pardon; administrations stand beyond courtesy), Air France reimburses me and I buy a train ticket; during my vacation I pay everywhere with my credit card and each of my meals is registered at the Paris bank and thereby made available to other bureaucrats, for instance the ones at the tax bureau or, should I ever be suspected of a crime, the police. For my little vacations a whole brigade of bureaucrats moves into action, and I turn myself into a bureaucrat of my own life (filling out questionnaires, submitting claims, filing documents in my own archives).

The difference between my parents' life and mine is striking: the bureaucracy has infiltrated the whole tissue of life. "Never till now, anywhere, had K. seen the administration and life so thoroughly enmeshed, so enmeshed that it sometimes seemed that the administration and life had changed places" (*The Castle*). Suddenly every concept of existence has shifted meaning:

The concept of *freedom*: there is no institution that prohibits the surveyor K. from doing as he wants; but with all that freedom, what can he actually do? What can a citizen, with all his rights, change about his immediate environment, about the parking lot being built below his house, about the howling loudspeaker set up across from his windows? His freedom is limitless, and powerless.

The concept of *private life*: no one means to stop K. from making love to Frieda even though she is the mistress of the omnipotent Klamm; still, the eyes of the Castle follow K. everywhere, and his couplings are meticulously observed and noted; the two assistants assigned him are with him for that purpose. When K. complains of their intrusiveness, Frieda protests: "Darling, what have you got against the assistants? We have nothing to hide from them." No one will dispute our right to a private life, but it is no longer what it used to be: no secrecy protects it; wherever we may be, our traces remain in computers; Frieda says, "we have nothing to hide from them"; we no longer even demand secrecy; private life no longer demands privacy.

The concept of *time*: when one man conflicts with another, two equal times are in conflict: two limited times of perishable life. Well, these days we are confronting not one another but administrations, whose life knows neither youth, nor age, nor fatigue, nor death, and occurs *outside of human time*: man and administration experience two different times. In a newspaper I read the commonplace story of a small French industrialist whose business failed because his debtor had not paid him what was owed. He feels he is innocent, wants to defend himself in

court, but he gives up right away: his case could not be heard for four years. Procedure is long, life is short. Which reminds me of the merchant Block in Kafka's *The Trial*: his case has dragged on for five and a half years with no decision; meanwhile he has had to abandon his business because "if you want to do something for your trial, you can no longer attend to anything else." It is not cruelty that undoes the surveyor K. but the non-human time of the Castle; man asks for audiences, the Castle postpones them; litigation goes on, life ends.

Then, *adventure*: in other times the word used to express the excitement of life conceived as freedom; a courageous individual decision would unleash a surprising chain of actions, all of them free and intentional. But this concept of adventure does not correspond to what K. experiences. He arrives in the village because, through some misunderstanding between two departments at the Castle, he has been summoned there by error. It is not his own will but an *administrative error* that sets off his adventure, which has, ontologically, nothing to do with a Don Quixote's or a Rastignac's. Because of the immensity of the bureaucratic apparatus, errors become statistically inevitable; the use of computers renders them ever less easy to spot and ever more irreparable. In our lives, where everything is planned out, determined, the only possible unexpected event is some error of the administrative machinery with its unforeseeable consequences. Bureaucratic error becomes the only poetry (a dark poetry) of our time.

The concept of adventure is akin to that of *combat*; K. often uses this word when he speaks of his dispute with the Castle. But

what does his combat consist of? A few fruitless encounters with bureaucrats, and a long wait. No bodily struggles; they don't have bodies, our adversaries: insurance, social security, chamber of commerce, justice, tax bureau, police, prefecture, city hall. We battle by spending hours and hours in offices, waiting rooms, archives. At the end of the battle, what awaits us? A victory? Sometimes. But what's that? According to Max Brod's account, Kafka imagined this ending for *The Castle*: after all his troubles, K. dies of exhaustion; he is on his deathbed when (I quote Brod) "there arrives from the Castle the decision declaring that he has not really got the right to live in the village but that he is nonetheless authorized to live and work there in view of certain special circumstances."

The Ages of Life Concealed Behind the Curtain

I LET FILE PAST ME THE NOVELS I REMEMBER, AND I TRY TO make out the various ages of their protagonists. Curiously they are all younger than I recalled. That is because for their authors they represented a general human situation more than the specific situation of a character's age. After all his adventures, having come to understand that he no longer cares to live in the world around him, Fabrice del Dongo goes off to the Charterhouse of Parma. I have always adored that ending. But Fabrice is still very young. How long could a man of his age, no matter how sadly disappointed he may be, stand living in a monastery? Stendhal evades the question by letting Fabrice die after a sin-

gle year spent in the charterhouse. Mishkin was twenty-six, Rogozhin twenty-seven, Nastasya Filippovna twenty-five; Aglaia is only twenty and she is the one who, through her non-sensical actions, ends by destroying the lives of all the others. Yet the immaturity of these characters is not explored as such. Dostoyevsky is giving us the drama of human beings, not the drama of youth.

Romanian by birth, E. M. Cioran settles in Paris in 1937 at age twenty-six; ten years later he publishes the first of his books written in French and becomes one of the great French writers of his time. In the 1990s, Europe, once so indulgent toward nascent Nazism, now marches boldly forth to battle its ghosts. The time has come for a major settling of accounts with the past, and the fascist opinions of the young Cioran back when he was living in Romania suddenly become news. In 1995, at the age of 84, he dies. I open an important Paris newspaper and find a two-page spread of obituaries. Not a word on his sixty years of work; it is his Romanian youth that has disgusted, fascinated, infuriated, inspired his funerary scribes. They have robed the cadaver of the great French writer in a costume from Romanian folklore and forced it, in the coffin, to raise its arm in the fascist salute.

Some time later I read a text that Cioran wrote in 1949, when he was thirty-eight: "I could not even imagine my past; and when I think of it now, it seems to be showing me the life of some *other person*. And that other person is what I repudiate; my whole 'self' is someplace else, a thousand leagues away from the person he was." And farther on: "When I think back . . . to all the delirium of my then self . . . I seem to be observing the obsessions

of a stranger, and I am stupefied to learn that that stranger was myself."

What interests me in this piece is the *amazement* of the man who cannot find any link between his present "self" and the past one, who is stupefied before the enigma of his identity. But, you'll say, is that amazement sincere? Certainly it is! In its usual version everyone has experienced it: How in the world could I ever have taken seriously that philosophical (or religious, artistic, political) trend? or else (more banally): How could I have fallen in love with such a silly woman (stupid man)? Well, whereas for most people, youth goes by fast and its mistakes evaporate without leaving much trace, Cioran's turned to stone; one cannot laugh off a ridiculous sweetheart and fascism with the same condescending smile.

Stupefied, Cioran looked back on his past and flew into a rage (I am still quoting from that same 1949 text): "Evil is the doing of young people. They are the ones who advocate doctrines of intolerance and put them into practice; they're the ones who have need of blood, shouting, turbulence, and barbarism. At the time when I was young, all of Europe had faith in youth, all of Europe urged the young into politics, into affairs of state."

How many Fabrices, Aglaias, Nastasyas, Mishkins I see around me! They are all just beginning the journey into the unknown; no question, they are drifting, but theirs is a singular sort of drifting: they drift without knowing that's what they are doing; for they are doubly inexperienced: they do not know the world and they do not know themselves; only when they look back on it from the distance of adulthood will they see their

drifting as drifting; and besides: only with that distance will they be capable of understanding the very notion of drifting. For the moment, with no understanding of the view the future will one day take of their long-gone youth, they defend their convictions far more aggressively than an adult man would defend his, a man who has had experience with the fragility of human certainties.

Cioran's outburst against youth shows something obvious: from each observation post standing along the line that runs from birth to death, the world looks different and the attitudes of the person looking out from it change as well; no one will understand another person except *by first of all* understanding his age. Of course that's so obvious, so very obvious! But only an ideological pseudo-obviousness can be seen at once. With an existential obviousness, the more obvious it is, the less visible. The ages of life stand concealed behind the curtain.

Morning Freedom, Evening Freedom

WHEN PICASSO PAINTED HIS FIRST CUBIST PICTURE, HE was twenty-six: all over the world several other painters of his generation joined up and followed him. If a sixty-year-old had rushed to imitate him by doing cubism at the time, he would have seemed (and rightly so) grotesque. For a young person's freedom and an old person's freedom are separate continents.

"Young, you are strong in company; old, in solitude," wrote Goethe (the old Goethe) in an epigram. Indeed, when young

people set about attacking acknowledged ideas, established forms, they like to do it in bands; when Derain and Matisse, at the start of the past century, spent long weeks together on the beaches of Collioure, they were painting pictures that looked alike, were marked by the same Fauve aesthetic; yet neither thought of himself as the epigone of the other—and indeed, neither was.

In cheerful solidarity the surrealists saluted the 1924 death of Anatole France with a memorably foolish obituary pamphlet: "Cadaver, we do not like your brethren!" wrote poet Paul Éluard, age twenty-nine. "With Anatole France, a bit of human servility departs the world. Let there be rejoicing the day we bury guile, traditionalism, patriotism, opportunism, skepticism, realism and heartlessness!" wrote André Breton, age twenty-eight. "May he who has just croaked . . . take his turn going up in smoke! Little is left of any man: it is still revolting to imagine about this one that he ever even existed!" wrote Louis Aragon, age twenty-seven.

I think again of Cioran's words about the young and their need for "blood, shouting, turbulence"; but I hasten to add that those young poets pissing on the corpse of a great novelist were nonetheless real poets, admirable poets; their genius and their foolishness sprang from the same source. They were violently (lyrically) aggressive toward the past and with the same (lyrical) violence were devoted to the future, of which they considered themselves the legal executors and which they knew would bless their joyous collective urine.

Then comes the moment when Picasso is old. He is alone,

abandoned by his crowd, and abandoned as well by the history of painting, which in the meantime had gone in a different direction. With no regrets, with a hedonistic delight (his painting had never brimmed with such good humor), he settles into the house of his art, knowing that the New is to be found not only up ahead on the great highway, but also to the left, the right, above, below, behind, in every possible direction from the inimitable world that is his alone (for no one will imitate him: the young imitate the young; the old do not imitate the old).

It is not easy for an innovative young artist to seduce the public and make himself beloved. But later on when, inspired by his vesperal freedom, he once again transforms his style and abandons the image people had of him, the public hesitates to follow him. Linked with the young world of Italian cinema (that great cinema that no longer exists), Fellini enjoyed unanimous admiration for a long time; *Amarcord* (1973) was the last of his films on whose poetic beauty everyone agreed. After that his fantasy gets still wilder and his gaze sharpens; his poetry turns antilyrical, his modernism antimodern; the seven films of his last fifteen years are an implacable portrait of the world we live in: *Casanova* (the image of show-off sexuality, taken to grotesque extremes); *Orchestra Rehearsal*; *City of Women*; *And the Ship Sails On* (a farewell to the Europe whose ship is sailing into the void, to the accompaniment of opera arias); *Ginger and Fred*; *Interview* (a great farewell to cinema, to modern art, to art pure and simple); *The Voice of the Moon* (a final farewell). Over the course of those years, irritated both by his very demanding aesthetic and by the disenchanted gaze he leveled at their contemporary world, fash-

ionable society, the press, the audience (and even the producers) turned away from him; no longer obligated to anyone, he savored the "joyful irresponsibility" (his words) of a freedom he had never known before.

During his last ten years, Beethoven has nothing more to expect from Vienna, from its aristocracy, from its musicians who honor him but no longer listen to him; nor does he listen to them, actually, if only because he is deaf; he is at the peak of his art; his sonatas and quartets are like nothing else; in the complexity of their construction they are far from classicism yet do not come close to the facile spontaneity of the young Romantics; in the evolution of music he has gone off in a direction where no one has followed; without disciples, without successors, the work from his vesperal freedom is a miracle, an island.

Part Seven

THE NOVEL, MEMORY, FORGETTING

Amélie

EVEN WHEN NO ONE READS FLAUBERT ANYMORE, THE phrase "Madame Bovary is me" will not be forgotten. That famous line: Flaubert never wrote it. We owe it to a Miss Amélie Bosquet, a mediocre novelist who showed her fondness for her friend Flaubert by panning *Sentimental Education* in two exceptionally nitwitted articles. To some person whose name remains unknown, that Amélie confided a very precious bit of information: that she once asked Flaubert what woman was the model for Emma Bovary, and that he supposedly replied, "Madame Bovary is me!" Much struck by this, the unknown person passed along the information to a certain M. Deschermes who, also much struck, spread it about. The mountains of commentary inspired by that apocryphal item say a great deal about the futility of literary theory which, helpless before a work of art, endlessly spouts platitudes about the author's psyche. They also say a lot about what we call memory.

Forgetting That Erases, Memory That Transforms

I REMEMBER REUNIONS OF MY HIGH SCHOOL CLASS TWENTY years after graduation: J. greeted me with delight, "I can still see you telling the math teacher, 'Shit, Sir!' Now, the sound of the word "shit" in Czech has always repelled me, and I was absolutely certain that I never said that. But everyone around us burst into guffaws, pretending to recall my fine sally. Understanding that my denial would convince no one, I smiled modestly and without protesting, for, I add to my shame, I was pleased to find myself transformed into a hero spitting the dirty word into the face of the damned professor.

Everyone has had such experiences. When someone quotes what you said in a conversation, you never recognize yourself; your remarks are at best brutally simplified, sometimes corrupted (when he's taken your irony seriously), and very often they do not correspond to anything you might ever possibly have said or thought. And you should not be astonished or incensed, for this is the most obvious thing in the world: man is separated from the past (even from the past only a few seconds old) by two forces that go instantly to work and cooperate: the force of forgetting (which erases) and the force of memory (which transforms).

It is the most obvious thing, but it is hard to accept, for when one thinks it all the way through, what becomes of all the testimonies that historiography relies on? What becomes of our certainties about the past, and what becomes of History itself, to which we refer every day in good faith, naively, spontaneously? Beyond the slender margin of the incontestable (there is no doubt

148

that Napoleon lost the battle of Waterloo), stretches an infinite realm: the realm of the approximate, the invented, the deformed, the simplistic, the exaggerated, the misconstrued, an infinite realm of nontruths that copulate, multiply like rats, and become immortal.

The Novel as Utopia of a World That Has No Forgetting in It

THE PERPETUAL ACTIVITY OF FORGETTING GIVES OUR EVERY act a ghostly, unreal, hazy quality. What did we have for lunch the day before yesterday? What did my friend tell me yesterday? And even: What was I thinking about, three seconds ago? All of that is forgotten and (what's a thousand times worse!) it deserves no better. Against our real world, which, by its very nature, is fleeting and worthy of forgetting, works of art stand as a different world, a world that is ideal, solid, where every detail has its importance, its meaning, where everything in it—every word, every phrase—deserves to be unforgettable and was conceived to be such.

Still, the perception of art does not escape the force of forgetting either. Though it should be said that each art has a different relation to forgetting. From that standpoint poetry is privileged. A person reading a Baudelaire sonnet cannot skip a single word. If he loves it he will read it several times and perhaps aloud. If he adores it, he will learn it by heart. Lyric poetry is a fortress of memory.

The novel, on the other hand, is a very poorly fortified castle.

If I take an hour to read twenty pages, a novel of four hundred pages will take me twenty hours, thus about a week. Rarely do we have a whole week free. It is more likely that, between sessions of reading, intervals of several days will occur, during which forgetting will immediately set up its worksite. But it is not only in the intervals that forgetting does its work; it participates in the reading continuously, with never a moment's lapse; turning the page, I already forget what I just read; I retain only a kind of summary indispensable for understanding what is to follow, but all the details, the small observations, the admirable phrasings are already gone. Erased. Someday, years later, I will start to talk about this novel to a friend, and we will find that our memories have retained only a few shreds of the text and have reconstructed very different books for each of us.

And yet the novelist writes his novel as if he were writing a sonnet. Look at him! He is amazed at the composition he sees taking shape before him: the least detail is important to him, he makes it into a motif and will bring it back in dozens of repetitions, variations, allusions, like a fugue. And so he is sure that the second half of his novel will be even finer, stronger, than the first; for the farther one progresses through the castle's halls, the more the echoes of phrases already pronounced, themes already set out, will multiply and, brought together into chords, they will resonate from all sides.

I think of the last pages of *Sentimental Education*: long after he has broken off his flirtations with History, seen Madame Arnoux for the last time, Frédéric finds himself with Deslauriers, his boyhood friend. Melancholy, they talk about their first trip to

a brothel: Frédéric was fifteen, Deslauriers eighteen; they arrived like suitors, each bearing a fat bouquet of flowers; the girls laughed, Frédéric ran off in a panic of shyness, and Deslauriers followed him. The memory is beautiful, for it reminds them of the old friendship, which they have since betrayed many times but which, seen from thirty years' distance, remains a value, perhaps the most precious value, even if they no longer possess it. "That was the best time of our lives," Frédéric says, and Deslauriers repeats the line, which brings to a close both their sentimental education and the novel.

That ending did not win much approval. It was called vulgar. Vulgar? Really? I could imagine a different, more convincing objection: that ending a novel with a brand-new motif is a compositional fault; as if in the final bars of a symphony, instead of returning to the principal theme, the composer suddenly slipped in a new melody.

Yes, this alternative objection is more convincing, except that the motif of the brothel visit is not new; it has not appeared "suddenly"; it was set out early in the novel, at the end of the second chapter of part 1: the very young Frédéric and Deslauriers have spent a fine day together (the whole chapter is given over to their friendship) and, as they take leave of one another, they look over at "the left bank [where] a light is shining in the attic window of a low-built house." Deslauriers pulls off his hat with a theatrical flourish and declaims a few enigmatic lines. "This allusion to a shared adventure delighted them. They went laughing noisily through the streets." Yet Flaubert does not say what that "shared adventure" was; he waits to tell us till the end of the novel, so that

the echo of happy laughter (the laughter that sounded "noisily through the streets") should blend with the melancholy of the last lines in a subtle chord.

But if throughout the writing of the novel Flaubert was hearing that lovely laughter of friendship, the reader by contrast has instantly forgotten it, and when he gets to the end, the evocation of the bordello visit wakes no memory in him; he does not hear the music of a subtle chord.

What should the novelist do in the face of that destructive forgetting? Snap his fingers at it and build his novel as an indestructible castle of the unforgettable, even though he knows that his reader will only ramble through it distractedly, rapidly, forgetfully, and never inhabit it.

Composition

ANNA KARENINA IS MADE UP OF TWO NARRATIVE LINES: Anna's (the drama of the adultery and the suicide) and Levin's (the life of a fairly happy couple). At the end of the seventh part, Anna kills herself. There follows the last part, the eighth, devoted exclusively to the Levin line. This is a very sharp violation of convention, because for any reader the heroine's death is the only possible ending to a novel. Well, in that eighth part, the heroine is no longer onstage; all that remains of her story is a trailing echo, the light tread of a memory growing faint; and it is lovely; and it is truthful; Vronsky alone is in despair, and he goes off to Serbia to seek death in the war against the Turks; and even the grandeur of

his act is relativized: the eighth part takes place almost entirely on Levin's farm where, in the course of conversation, Levin mocks the pan-Slav hysteria of the volunteers marching off to fight for the Serbs; besides, that war concerns Levin far less than do his meditations on man and on God; these surface in fragments during his farming activities, mingled with the prose of his daily life, which closes like a final forgetting over a drama of love.

In placing Anna's story in the vast space of the world where she finally melts into the immensity of time governed by forgetting, Tolstoy has obeyed the fundamental propensity of the art of the novel. For narration as it exists since the dawn of time became the novel when the author was no longer content with a mere "story" but opened windows onto the world that stretched all around. Thus were joined to a "story" other stories, episodes, descriptions, observations, and reflections, and the author was faced with very complex, very heterogeneous material onto which he was obliged, like an architect, to impose a form; in that same way, for the art of the novel from its birth, composition (architecture) took on primordial importance.

This exceptional importance of composition is one of the genetic markers of the art of the novel; it distinguishes that art from the other literary arts, from theater works (their architectural freedom is strictly limited by the duration of a performance and by the need to capture and hold continuously the attention of the spectator) as well as from poetry. In that regard, is it not almost shocking that Baudelaire, the incomparable Baudelaire, was able to utilize the same alexandrines and the same sonnet form as innumerable throngs of poets before and after him? But such is the

poet's art: his originality is manifested by the force of imagination, not by the architecture of the whole; by contrast, the beauty of a novel is inseparable from its architecture; I say "beauty" because the composition is not merely a technical skill; it carries within it an author's originality of style (all Dostoyevsky's novels are based on the same compositional principle); and it is the identifying mark of each particular novel (inside this common principle, each of Dostoyevsky's novels has its own inimitable architecture). The importance of the composition may be even more striking in the great novels of the twentieth century: *Ulysses*, with its array of different styles; *Ferdydurke*, whose "picaresque" story is divided into three parts by the two farcical interludes that have no relation to the novel's action; the third volume of *The Sleepwalkers*, which brings into one integrated whole five different "genres" (novel, short story, reportage, poetry, essay); Faulkner's *The Wild Palms*, made up of two entirely autonomous stories that never intersect; and so on. . . .

When, one day, the novel's history will have ended, what fate will await the great novels left after that? Some are unrecountable, and thus inadaptable (like *Pantagruel*, like *Tristram Shandy*, like *Jacques the Fatalist*, like *Ulysses*). They will either survive or disappear as they are. Others, thanks to the "story" they contain, do seem recountable (like *Anna Karenina, The Idiot, The Trial*) and therefore adaptable to film, to television, to theater, to cartoon strip. But that "immortality" is a chimera! For turning a novel into a theater piece or a film requires first decomposing the composition; reducing it to just its "story"; renouncing its form. But what is left of a work of art once it's

stripped of its form? One means to prolong a great novel's life through an adaptation and only builds a mausoleum, with just a small marble plaque recalling the name of a person who is not there.

A Forgotten Birth

THESE DAYS, WHO STILL REMEMBERS THE INVASION OF Czechoslovakia by the Russian army in August 1968? In my life it was a conflagration. And yet, if I were to write down my recollections of that time, the results would be paltry, certainly full of errors, of unwitting lies. But alongside the *factual memory* there is another sort: my little country seemed to me stripped of the last shred of its independence, swallowed up *forever* by an enormous alien world; I believed I was watching the start of its death throes; of course, my evaluation of the situation was wrong, but despite my error (or perhaps because of it) a great experience was engraved on my *existential memory*: ever since then, I know what no Frenchman, no American, can know: I know what it is for a man to live through the death of his nation.

Hypnotized by the image of its death, I reflected on its birth, or more precisely its second birth, its rebirth after the seventeenth and eighteenth centuries, during which, with the disappearance of books, of schools, of governments, the Czech language (in earlier days the great language of Jan Hus and of Comenius) limped along beside German as a household dialect; I thought about the Czech writers and artists of the nineteenth century who, within a

miraculously brief span of time, had awakened a dormant nation; I thought about Bedrich Smetana, who did not even know how to write correct Czech, who kept his diaries in German, and was nonetheless the nation's most emblematic figure. A unique situation: the Czechs, all of them bilingual, then had the chance to choose: to be born or not be born; to be or not to be. One of them, Hubert Gordon Schauer, had the courage to lay out frankly the essence of the stakes. "Would we not be more useful to humanity if we joined our spiritual energy to the culture of a great nation that is already at a far higher level than the nascent Czech culture?" And still, in the end they chose "a nascent culture" over the mature culture of the Germans.

I have tried to understand them. What was the magic in the appeal to patriotism? Was it the charm of a journey into the unknown? Nostalgia for the great past that had disappeared? Some noble generosity that prefers the weak to the powerful? Or was it the pleasure of belonging to a band of friends eager to create a new world *ex nihilo*? To create not merely a poem, a theater, a political party, but a whole nation, even with its half-lost language? Separated as I was from that period by only three or four generations, I was surprised by my inability to put myself in my ancestors' skin, to re-create in imagination the concrete situation they had experienced.

Russian soldiers were ambling through the streets, I was terrified at the idea that a crushing force was going to stop us from being what we had been, and at the same time I realized with astonishment that I did not know how and why we had become what we were; I wasn't even sure that, a century earlier, I would

have chosen to be Czech. It was not the knowledge of historical events that I lacked. I needed some other kind of knowledge, the kind that, as Flaubert would have said, goes into "the soul" of a historical situation, that grasps its human content. Perhaps a novel, a great novel, could have made me understand how the Czechs of that time had experienced their decision. Well, such a novel has not been written. There are cases where nothing can make up for the absence of a great novel.

Unforgettable Forgetting

SOME MONTHS AFTER I HAD LEFT FOREVER MY LITTLE KID-napped country, I was visiting Martinique. Perhaps I was trying to forget my émigré condition for a while. But that was impossible: hypersensitive as I was to the fate of small countries, everything down there reminded me of my Bohemia, all the more since my encounter with Martinique took place at the moment when its culture was engaged in a passionate quest after its own personality.

What did I know about that island at the time? Nothing. Except the name of Aimé Césaire, whose poetry I had read in translation when I was seventeen, right after the war, in a Czech avant-garde literary magazine. To me, Martinique was the island of Aimé Césaire. And indeed, that is how it seemed when I set foot on it. Césaire was the mayor of the capital, Fort-de-France. Every day crowds waited at the town hall to talk to him, confide in him, ask his advice. I will certainly never again see

such an intimate, physical connection between a people and their representative.

The poet as founder of a culture, of a nation—that I had been quite familiar with in my Central Europe; such were Adam Mickiewicz in Poland, Sándor Petöfi in Hungary, Karel Hynek Macha in Bohemia. But Macha was a *poète maudit*, Mickiewicz an émigré, Petöfi a young revolutionary killed in battle in 1849. It had not been granted them to experience what Césaire did: the openly declared love of his people. And then, Césaire is not a nineteenth-century Romantic, he is a modern poet, Rimbaud's heir, friend to the surrealists. If the literature of the small Central European countries is rooted in the culture of romanticism, that of Martinique (and that of all the Antilles) is born (and this amazed me!) of the aesthetic of modern art!

It was a poem by the young Césaire that set it all off: *Notebook of a Return to the Native Land* (1939): the return of a negro to an Antillean island of negroes. With no romanticism, no idealization (Césaire does not speak of "blacks," he purposely uses the term "negroes"), the poem wonders, harshly: *Who are we?* Good Lord, who are they indeed, these Blacks of the Antilles? They were deported to the place from Africa in the seventeenth century—but from where, exactly? What tribe had they belonged to? What had their language been? The past was forgotten. Guillotined. Guillotined by a long journey in ships' holds, among corpses, screams, tears, blood, suicides, murders; nothing was left at the end of that journey through hell; nothing but forgetting: *fundamental and foundational forgetting*.

The unforgettable shock of forgetting had transformed the

island of slaves into a theater of dreams; for only through dreaming could the Martinicans imagine their own existence, create their *existential memory*; the unforgettable shock of forgetting had lifted their village storytellers to the rank of *poets of identity* (it was to honor them that Patrick Chamoiseau wrote his *Solibo magnifique*) and would later bequeath their sublime oral heritage, with its fantasies and follies, to the novelists. I loved these novelists, they were strangely near to me (not only the Martinicans but also some Haitians: René Depestre, an émigré like myself, and Jacques Stephen Alexis, executed in 1961, as was Vladislav Vancura, my first literary love, in Prague twenty years earlier). Their novels were very original (dream, magic, fantasy playing a notable role) and important not only for their islands but also (a rare thing I emphasize) for the modern art of the novel, for *world literature*.

A Forgotten Europe

AND WE IN EUROPE—WHO ARE WE?

I think of the line Friedrich Schlegel wrote in the last years of the eighteenth century: "The French Revolution, Goethe's *Wilhelm Meister*, and Fichte's *Epistemology* are the most important trends of our era." Putting a novel and a philosophy book on the same plane as an enormous political event—that was Europe; the Europe born with Descartes and Cervantes: the Europe of Modern Times.

Difficult to imagine, thirty years ago, someone writing (for instance): "Decolonization, Heidegger's critique of technology,

and Fellini's films embody the most important trends of our era." That way of thinking no longer reflected the spirit of the time.

And now? Who would dare to attribute equal importance to a cultural work (of art, of thought) with (for instance) the fall of Communism in Europe?

Does work of such importance no longer exist?

Or have we lost the capacity to recognize it?

These questions have no meaning. The Europe of Modern Times is gone. The Europe we live in no longer looks for its identity in the mirrors of its philosophy and its arts.

But where then is the mirror? Where shall we go to find our face?

The Novel as Journey Through the Centuries and the Continents

THE HARP AND THE SHADOW (1979), A NOVEL BY ALEJO Carpentier, is made up of three parts. The first is set in the early nineteenth century in Chile, where the future Pope Pius IX is spending a while; convinced that the discovery of the new continent was the most glorious event of modern Christianity, he decides to dedicate his life to the beatification of Christopher Columbus. The second part sends us back some three centuries before that: Christopher Columbus himself recounts the amazing adventure of his discovery of America. In the third part, some four centuries after his death, Christopher Columbus, invisible, sits in on the session of the ecclesiastical tribunal that, after a discussion

that is as fantastical as it is erudite (we are in the post-Kafka era, where the frontier of the implausible is no longer under guard), denies him beatification.

Integrating different historical eras into a single composition that way: this is one of the new possibilities, previously unthinkable, that opened before the art of the novel in the twentieth century, once it learned to breach the barriers of its fascination with individual psychologies and to consider the existential problematic in the broad, general, superindividual sense of the word; again I refer to *The Sleepwalkers*, in which Hermann Broch shows European life carried away by the torrent of the "degradation of values" by examining three separate historical eras, three steps by which Europe descended toward the ultimate crumbling of its culture and of its reason for being.

Broch inaugurated a new path for the novel form. Is it the same path for Carpentier's work? It certainly is. No great novelist can exit from the history of the novel. But behind the sameness in form hide different purposes. In juxtaposing diverse historical eras, Carpentier is not looking to solve the mystery of a Great Death Throe; he is not a European; on his clock (the clock of the Antilles and of all Latin America) the hands are still far from midnight; he is not asking "Why do we have to disappear?" but "Why did we have to be born?"

Why did we have to be born? And who are we? And what is our land, our *terra nostra*? We will not understand much if we are content to plumb the enigma of identity with only the help of introspective memory. To understand we must compare, Broch said; must put identity to the test of comparisons; we must (as

Carpentier did in his 1958 book *The Age of Enlightenment*) compare the French Revolution with its Antillean responses (the Paris guillotine with Guadeloupe's); an eighteenth-century Mexican colonist must fraternize in Venice with Handel, Vivaldi, Scarlatti (even Stravinsky and Louis Armstrong are present in their nocturnal revels!) to show us (in Carpentier's 1974 novel *Concerto Barocco*) a fantastical encounter between Latin America and Europe; a love affair between a laborer and a prostitute, in Jacques Stephen Alexis's *In the Blink of an Eye* (1959), must unfold in a Haitian brothel against the backdrop of a totally alien world represented by the clientele of North American sailors; because the comparison between the English and Spanish conquests of America is everywhere in the air: "Open your eyes, Miss Harriet, and remember how we killed our Redskins and Never had the courage to fornicate with the squaws and at least create a half-breed nation," says the protagonist of Carlos Fuentes's novel *The Old Gringo* (1983), an aging North American who has wandered into the Mexican revolution; with these words he gets at the difference between the two Americas and, at the same time, two opposing archetypes of cruelty: the type anchored in contempt (which prefers to kill while at a distance, without touching the enemy, without even seeing him) and the type that feeds on a perpetual intimate personal contact (which wants to kill while looking the enemy straight in the eye).

The passion for comparison in all novelists is at once the desire for some air, some space, some breathing room: the desire for new forms; I think of Fuentes's *Terra Nostra* (1975), that immense journey across centuries and continents; in it we keep

meeting the same characters who, through the author's intoxicated fantasy, are reincarnated under the same name at different periods; their presence provides unity to an amazing composition that in the history of novelistic forms stands at the farthest frontier of the possible.

The Theater of Memory

TERRA NOSTRA GIVES US A MAD SCIENTIST CHARACTER WHO has a curious laboratory, a "theater of memory," where a fantastic medieval mechanism allows him to project on a screen not only every event that ever occurred but also those that *could have* occurred; according to him, alongside "scientific memory" there is such a thing as "poet's memory," which, by adding actual history and all the events that were possible, contains the "total knowledge of a total past."

As if he were inspired by his mad scientist, in *Terra Nostra*, Fuentes brings onstage historical figures of Spain, kings and queens, but their adventures bear no resemblance to what actually did happen; what Fuentes projects on the screen of his own "theater of memory" is not the history of Spain; it is a *fantasy variation on the theme of Spanish history*.

Which reminds me of a very amusing passage in *Pomysl (Idea)* by Kazimierz Brandys (1974): At an American university, a Polish émigré is teaching the history of his country's literature; knowing that no one has any idea of it, he invents for his own amusement a fictive literature, made up of writers and works that have never

existed. At the end of the university year, he is strangely disappointed to realize that this imaginary history differs in no essential way from the real thing, that he has invented nothing that could not have occurred, and that his hoaxes are a faithful reflection of the sense and the essence of Polish literature.

Robert Musil too had a "theater of memory"; there he observed the activity of a powerful Viennese institution, "Collateral Campaign," as it prepared for the 1918 celebration of the Emperor's birthday, with the aim of making it into a great pan-European Peace Jubilee (yes, another enormous black joke!); all the action of *The Man Without Qualities*, deployed over two thousand pages, is bound up with that important intellectual, political, diplomatic, and social institution that never existed.

Fascinated by the secrets of modern man's existence, Musil considered historical events to be (I quote) *vertauschbar*—interchangeable, permutable; for the dates of wars, the names of victors and vanquished, various political initiatives, all result from the play of variations and permutations whose limits are determined by deep, hidden forces. Often these forces manifest in ways that are far more revealing in some other variation of History than the one that did happen to play out.

Consciousness of Continuity

YOU SAY THEY DETEST YOU? BUT WHAT DOES "THEY" mean? Everyone detests you a different way, and you can be sure that among them there are some who love you. Through its pres-

tidigitation, grammar can transform a multitude of individuals into a single entity, a single subject, a single "subjectum" that is called "we" or "they" but that does not exist as a concrete reality. Old Addie dies in the midst of her large family. Faulkner (in his novel *As I Lay Dying*, 1930) recounts her long journey in the coffin to the cemetery in a remote corner of America. The protagonist of the story is a collectivity, a family; it is *their* corpse, *their* journey. Yet, by the form of the novel, Faulkner gets around the trick of the plural; for it is not a single narrator but the characters themselves (there are fifteen of them) who (in sixty short chapters) all recount, each in his own way, that anabasis.

The inclination to demolish the *grammatical trickery of the plural* and, with it, *the power of the single narrator*, an inclination so striking in this Faulkner novel, has been present—in germ, as a possibility—in the art of the novel since its birth; and, in a nearly programmatic way, in the "epistolary novel" form that was widespread during the eighteenth century. This form abruptly reversed the power ratio between story and characters: it was no longer a story's logic that by itself determined which character would come onstage when; now the characters were breaking loose, were appropriating total freedom of speech, were themselves becoming the rule-makers—for, by definition, a letter is the expression of a correspondent who talks about whatever he likes, who is free to digress, to move from one subject to another.

I am dazzled when I think of the form of the "epistolary novel" and its enormous possibilities; and the more I think about it, the more I feel that those possibilities remain unused, even unperceived: ah, how naturally the author could have put

together in one surprising whole all sorts of digressions, episodes, ruminations, ideas, memories, could have juxtaposed various versions and interpretations of the same event! Alas, the "epistolary novel" had its Richardson and its Rousseau, but no Laurence Sterne; he renounced its freedoms, hypnotized as he was by the despotic authority of "story." And I remember Fuentes's mad scientist, and think how the history of an art (an art's "total past") is made not only of what that art did create but also of what it *could have* created, of all its achieved works as well as of its possible and unrealized works; but never mind: there does remain, out of all those "epistolary novels," one very great book that has stood against time: *Dangerous Liaisons* (1782) by Choderlos de Laclos: that's the novel I think of when I read *As I Lay Dying*.

From the family likeness of these two works, what emerges is not that one was influenced by the other but that they belong to the same history of the same art, and they deal with a same great problem which that history sets before them: the problem of the abusive power of the single narrator; separated by so long a period of time, the two works are caught up in the same desire to break that power, to dethrone the narrator; (and their revolt aims at not only the narrator in the literary-theory sense, but it also attacks the atrocious power of that Narrator who, from time immemorial, has been telling Mankind one single approved, imposed version of everything there is). Seen against the backdrop of *Dangerous Liaisons*, the unusual form of Faulkner's novel reveals all its deep meaning, just as, conversely, *As I Lay Dying* makes visible the enormous artistic audacity of Laclos, who could throw light on a single

"story" from several angles and made his novel a carnival of separate truths and of their irreducible relativity.

It can be said of all novels: their common history puts them in many mutual relationships which illuminate their meaning, extend their effect, and protect them against forgetting. What would we still have of François Rabelais if Sterne, Diderot, Gombrowicz, Vancura, Grass, Gadda, Fuentes, García Márquez, Kiš, Goytisolo, Chamoiseau, Rushdie had not set ringing the echo of his lovely lunacies in their own novels? It is by the light from *Terra Nostra* (1975) that *The Sleepwalkers* (1929–32) displays the full significance of its aesthetic novelty, which was barely perceptible at the time of its publication; and it is in the company of those two works that Salman Rushdie's *The Satanic Verses* (1988) ceases to be a merely ephemeral political news item and becomes a great work that, with its oneiric juxtapositions of eras and continents, develops the most audacious possibilities of the modern novel. And *Ulysses*! It can be understood only by someone familiar with the novel's old passion for the mystery of the present moment, for the richness contained in a single second of life, for the existential scandal of insignificance. Taken outside the novel's history, *Ulysses* would be no more than a caprice, the incomprehensible extravagance of a madman.

Torn away from the history of their various arts, there is not much left to works of art.

Eternity

THERE WERE LONG PERIODS WHEN ART DID NOT SEEK OUT
the new but took pride in making repetition beautiful, reinforcing
tradition, and ensuring the stability of a collective life; music and
dance then existed only in the framework of social rites, of Masses
and fairs. Then one day in the twelfth century, a church musician
in Paris thought of taking the melody of the Gregorian chant,
unchanged for centuries, and adding to it a voice in counterpoint.
The basic melody stayed the same, immemorial, but the counter-
point voice was a new thing that gave access to other new things—
to counterpoint with three, four, six voices, to polyphonic forms
ever more complex and unexpected. Because they were no longer
imitating what was done before, composers lost anonymity, and
their names lit up like lanterns marking a path toward distant
realms. Having taken flight, music became, for several centuries,
the *history* of music.

All the European arts, each in its turn, took flight that way,
transformed into their own history. That was the great miracle of
Europe: not its art, but its art become history.

Alas, miracles do not endure for long. What takes flight will
one day come to earth. In anguish I imagine a time when art shall
cease to seek out the never-said and will go docilely back into the
service of the collective life that requires it to render repetition
beautiful and help the individual merge, at peace and with joy,
into the uniformity of being.

For the history of art is perishable. The babble of art is eternal.